IMAGES
of America

IOSCO COUNTY
THE PHOTOGRAPHY OF ARD G. EMERY
1892–1904

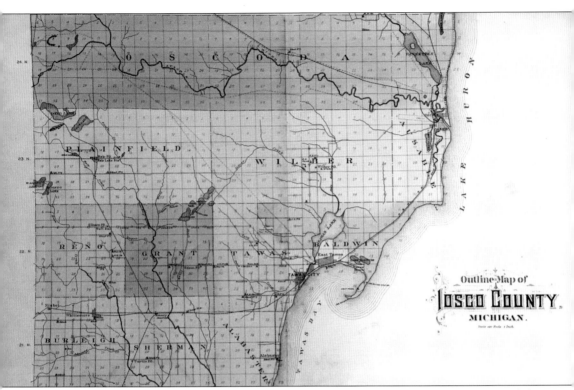

Iosco means "water of light," as defined by the Indian agent Schoolcraft, who frequented the area before its legal formation. In 1849, the first settlement on this area's Lake Huron shore was located at the mouth of the Au Sable River. In 1857, Iosco County was officially formed by the State of Michigan. Tawas City was established as the county seat in 1867. In 1900, the population of Iosco County was 10,246. This map is part of the 1903 Iosco County plat book.

On the Cover: Photographic artist Ard G. Emery moved into this studio and gallery on Newman Street in East Tawas in the summer of 1893. This photograph was taken in 1895 after mill workers from the Holland & Emery Lumber Company posed for Ard Emery's camera.

IMAGES of America
IOSCO COUNTY
THE PHOTOGRAPHY OF ARD G. EMERY
1892–1904

Huron Shores Genealogical Society
Foreword by H. Roger Miller

ARCADIA
PUBLISHING

Copyright © 2015 by Huron Shores Genealogical Society
ISBN 978-1-4671-1443-1

Published by Arcadia Publishing
Charleston, South Carolina

Printed in the United States of America

Library of Congress Control Number: 2015933060

For all general information, please contact Arcadia Publishing:
Telephone 843-853-2070
Fax 843-853-0044
E-mail sales@arcadiapublishing.com
For customer service and orders:
Toll-Free 1-888-313-2665

Visit us on the Internet at www.arcadiapublishing.com

For those who have lived, worked, and played in Iosco County

Contents

Foreword by H. Roger Miller				6

Acknowledgments					7

Introduction						8

1.	Ard Godfrey Emery, the Photographer		9

2.	Capturing History through the Viewfinder	19

3.	Focusing on Portraits in the Studio		59

Foreword

I first became aware of my great-great-great uncle Ard G. Emery when I came upon some family photographs that were taken by him during his time in East Tawas. Wanting to find out something about him, I turned to the Internet and found a site called *Lost Photographer Chronicler*, which had an extensive amount of researched background on his photographic career. Further research on ancestry.com and at historical resources in Maine, Wisconsin, Kansas, and Michigan helped me to fill in many of the blanks as they appeared.

What attracted me to this formerly unknown ancestor was the extensive career he experienced as a photographer and the amount of his work that has survived. Named as a merchant in the 1860 census, a photographer in the 1870 census, a farmer in the 1880 census, and a photographer again in 1892 in the *Iosco County Gazette*, it was obvious that Emery was a success. Many prominent institutions across America have examples of his work in their collections.

For the past 30 years, I have scoured local historical resources, newspapers, and other records to follow his travels about the country. I have also made it a point to collect any images of his that were selling for a reasonable price. I now have examples of his early stereo views of Lake Superior and portraits from his days in Ishpeming and Marquette, Michigan, portraits from his time in Junction City, Kansas, and portraits and local views from his time at East Tawas, Michigan.

I hope this book will help bring some of Ard G. Emery's many accomplishments to a wider audience beyond his family and the people of Iosco County. A big thank-you to Neil Thornton, who cared enough to see that so many of Ard's glass-plate negatives survived. A tip of the hat to the historians and genealogists of Iosco County for seeing the value in making sure they continue to survive.

— H. Roger Miller

Acknowledgments

First and foremost, the Huron Shores Genealogical Society expresses extreme gratitude to foreword author H. Roger Miller from Guelph, Ontario, for his valuable input and knowledge of the Emery family. Miller's constant contributions, guidance, and all-encompassing suggestions made this book better than ever imagined.

By the same token, many thanks are extended to Iosco County historian Neil Thornton for sharing his vast knowledge throughout this project. Thornton's input and cooperation ensured successful completion of this book.

Additionally, the Huron Shores Genealogical Society has appreciated the support of the Iosco County Historical Society and Museum. Unless otherwise noted, all images appear courtesy of Neil Thornton and the Iosco County Historical Society and Museum.

Indeed, the success of any group project depends largely on the support, encouragement, and dedication of the members within that group. Members of the Huron Shores Genealogical Society, who formed the core committee for this book project, can be praised for their loyal contributions and personal energies, which established the "heart and soul" of this book.

As chairperson of this project, Lugene Daniels was responsible for communicating and interacting with the Arcadia editing team, delegating the research and writing of fellow society members, and putting together and submitting the final layout for the book. Judy Sheldon worked closely with Daniels, and together they researched and wrote most of the captions and prepared the images for Arcadia. Alonzo Sherman steered all research efforts in the right direction. His continuous, unwavering presence in the Huron Shores Genealogical Society room at the Parks Library in Oscoda provided answers to questions whenever asked. Dan Stock and Jim Farrand donated time and energy in research, writing, and support. Lindsey Russell was responsible for proofreading the final written text.

Last, but not least, the Huron Shores Genealogical Society thanks several members and supporters who stepped forward and offered personal family history information. Among those who contributed were the following: Greta Anschuetz, Susan Cataline, Lawrence Daley, Valarie Frederickson, Dale Harwood, Barb Martin, Larry McLean, Mike McLean, Ron Roselli, Cathy Snider, Tony Stark, Gary Stemen, and Chuck Watson.

INTRODUCTION

Every photographer captures moments in time for one main purpose: to preserve that moment. Indeed, Ard G. Emery was like every other photographer in the world, no matter the era. He preserved moments that transformed the world, both then and now.

When Emery retired his East Tawas photography business in 1904, he left behind much of his work in a collection of nearly 5,000 glass negatives, stored in several wooden crates. Each glass negative was enclosed in a paper envelope that held the name of the customer. The customer's name was also written in India ink on the glass negative by Emery. Additionally, some of the negatives had been marked tally-style, indicating the number of photographs that were made for the customer.

East Tawas businessman Joseph Barkman rescued the boxes of glass negatives after Ard Emery's departure. For about two decades, Barkman, along with Neil Thornton, *Tawas Herald* journalist and Iosco County historian, popularized some of the images. Eventually, most of the collection was passed to the Iosco County Historical Society and Museum, where it is currently located.

In the 1990s, the glass negatives were cleaned and filed into new archival envelopes by members of the Huron Shores Genealogical Society. An index was also created. In 2008, members of the genealogical society scanned each negative, producing a digital image that could be shared more easily in the modern world of digitization. In addition, the index was updated. Since that time, the genealogical society has desired to produce a book to honor Emery's work.

Without a doubt, Ard G. Emery focused on making a significant impact on the lives of others through his artistic photographs. Many examples of his work have been preserved and archived in prestigious museums and institutions across America. Emery created his legacy through his photography, and that legacy will live on for future generations to experience and enjoy.

One

Ard Godfrey Emery, the Photographer

Ard Godfrey Emery was the middle child born to Temple Hosea Emery and Diana Godfrey in Orono, Penobscot County, Maine, on June 19, 1833. In 1839, one week after Ard's youngest brother was born, their father died. From that point, Diana Godfrey Emery reared five sons, all under the age of 11, to become productive and honorable men.

Throughout his young adult life, Ard G. Emery remained in Orono, working with his brothers. In the early 1860s, he followed the lumbering movement to northern Wisconsin. Soon after, his early photographic endeavor began in Hancock, followed by moves to Ishpeming and Marquette, all located in Michigan's Upper Peninsula.

In February 1865, Ard G. Emery married Agnes C. Cole in Marquette. The city became the birthplace of their four children: Diana, Lillie, Edwin Ard, and Arthur Lee. The family adopted an orphan, Charles Eklund Danielson, who had been born in Sweden and immigrated to America with his family about 1867.

In 1874, the entire Ard G. Emery family moved to Rockford, Illinois, where Ard sold sewing machines. It was here that Charles took the Emery surname. After a year in Rockford, the family migrated to Kansas, where Ard continued his photography vocation in various locations from 1876 until 1883. Sadly, Agnes suffered from a degenerative spinal disease. About the same time, Charles settled in Colorado, where he established a successful career as a photographer.

Agnes Cole Emery died in Pleasant Valley, Saline County, Kansas, in 1886. In November 1889, Ard married Martha E. Rogers, the divorced wife of William Greenman. Before her marriage to Greenman, Martha was the widow of Calvin Covington.

Ard G. Emery opened his East Tawas studio in January 1892. In late 1904, at age 71, he closed that studio. Ard and Martha departed Iosco County to retire in Elizabethtown, Tennessee. After Martha's death in 1911, Ard resided at the Masonic Home in Alma, Gratiot County, Michigan. He died there on April 20, 1923. He was buried with his brother John G. Emery at Oakwood Cemetery in Muskegon, Michigan.

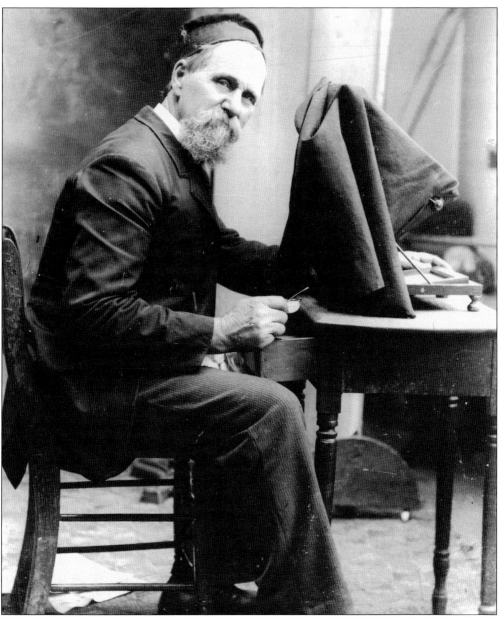

In 1891, the Tawas area was served unsatisfactorily by a photographer named J.M. Dafoe. Due to his frequent absences and failed promises to customers, the community sought his replacement. After spending the winter in Michigan, and learning that East Tawas offered a perfect place for a resident photographer, Ard G. Emery (pictured) opened his classic-Kodak studio for business on January 14, 1892. He leased this studio from Nelson Sims. Emery's wife, Martha, arrived two weeks later, and together they lived in a small, quaint residence beside the millinery store owned by Mrs. William Dennis. In July 1893, photographer Emery moved his studio to the recently renovated former Emery Brothers Company office building. This studio was located on Newman Street, between Barkman's clothing store and Wonzer's meat market. Dentist Dr. Botz moved his clinic to the vacant room on the north side of the gallery. Today, Barnacle Bill's restaurant marks the location of the former Emery portrait studio and gallery. (Courtesy of Neil Thornton.)

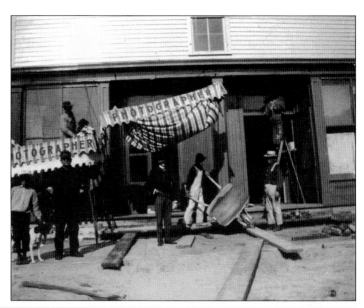

Photographer Ard G. Emery (center) poses in July 1893 while workers erect the awning and constructed a wooden plank walkway in front of his newly renovated studio. Located on the west side of Newman Street, the studio was near the famous Holland Hotel in East Tawas. It was considered one of the finest studios in northeastern Michigan. (Courtesy of Neil Thornton.)

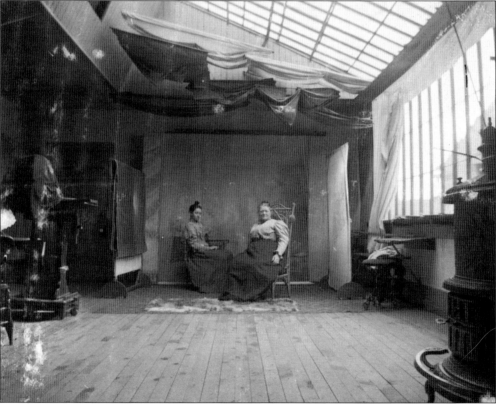

Ard Emery's wife, Martha (right), proudly poses in the new Newman Street studio with her friend Ida Say. The studio was located on the second floor. The north-facing wall bolstered the large glass panels. At this time, photography was rapidly changing the culture of America because it shaped how people remembered family, friends, and events. Photography had become affordable for all, not just the wealthy.

For the amateur, photography was not only difficult to learn but also expensive and potentially hazardous; however, through practice, they could master their craft. Most photographers of this era created portraits to earn a living, not to create art. Emery copied and enlarged portraits, which were then finished with crayon, ink, or pastel. He also used a flash unit that better captured images in low light. (Courtesy of Neil Thornton.)

Evelyn Louise Jackson (born September 1878) was the oldest daughter of *Iosco County Gazette* editor Charles R. Jackson and his wife, Mary Ellen Fisher. For this portrait, Evelyn promotes an advertising campaign for photographer Ard G. Emery. She graduated from East Tawas High School in 1897. In July 1904, at the home of her parents, Evelyn married Calvin H. Ramsay, an enterprising businessman from Angola, Indiana.

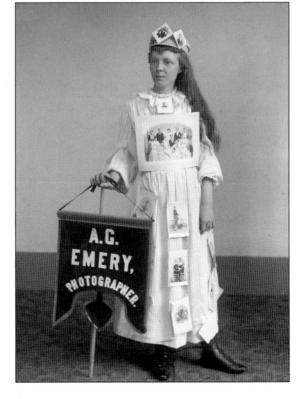

During the time that Ard G. Emery operated his East Tawas studio, the cabinet card was the most popular form of photographic portraiture. A thin-papered photograph was mounted on a card measuring 4.25 inches by 6.6 inches. Typically, the photographer's name and location were printed on the front of the card. This early Emery cabinet card displays the wedding photograph of German-born immigrants Rudolph Stark and Marie Geschke (at right), who married in Tawas City on November 27, 1892. Rudolph and Marie reared 11 children. Rudolph, a carpenter, owned the last steam-powered lumber mill in Tawas City. The back of this card (below) displays Ard Emery's handwriting and the price of the card, 75¢. The glass negative for this image has not been located within the collection. (Both courtesy of Tony Stark.)

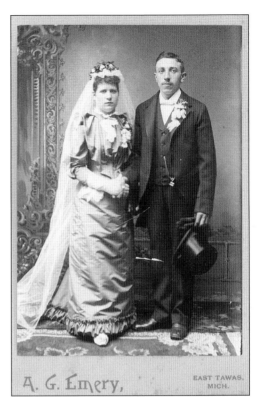

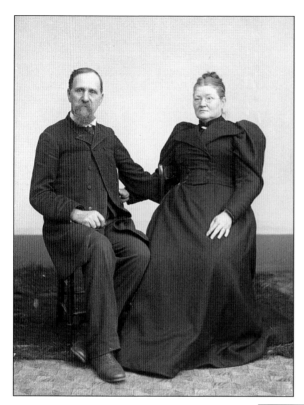

Martha Emma Rogers, born about 1842 in Tennessee, was Ard G. Emery's second wife. In the early 1860s, she married Calvin Covington, and they had two daughters: Mary Ann "Minnie" (born November 1864) and Cora L. (born July 1867). Shortly after the death of Calvin in 1877, Martha met William R. Greenman, whom she married on September 18, 1878, in Van Buren County, Michigan. Their marriage ended in divorce two years later. Martha and her two daughters relocated to Saline County, Kansas, where Cora died on October 3, 1885. Agnes Emery, who died on May 23, 1886, was laid to rest beside Cora at the Gypsum Hill Cemetery. Martha and Ard G. Emery (shown in both photographs) married in Kansas in November 1889. Martha died in Brooklyn, Kings County, New York, on April 17, 1911, and was interred at Green-Wood Cemetery in Brooklyn.

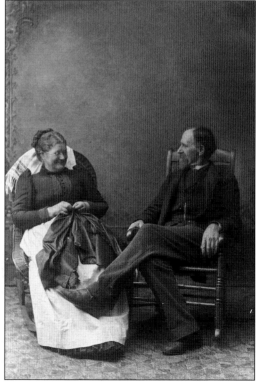

Arthur Lee Emery (on the left in both photographs) was the youngest child born to Ard G. Emery (at right, on the right) and his first wife, Agnes Cole. He was born on March 6, 1873, in Michigan's Upper Peninsula community of Marquette. At a young age, he moved to Kansas with his parents, where he spent most of his childhood. Arthur entered the military as a young man and participated in the Spanish-American War in 1898. Around 1899, he married May Alice Coolbroth (below, on the right). Arthur Lee Emery lived most of his adult life in the Brooklyn area of New York City with his wife and four sons. He was employed as a marine engineer by the Munson Steamship Line, whose headquarters were located at the Beaver Building in Lower Manhattan. After the company went out of business in 1937, Arthur and May continued to reside in Queens, New York.

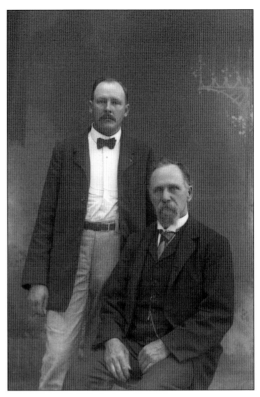

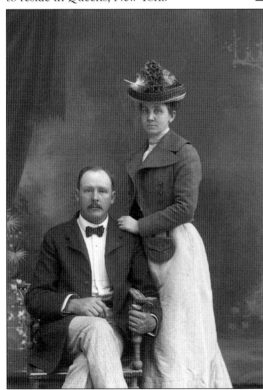

Mary Ann "Minnie" Covington (at left, on the left) was the oldest daughter of Martha E. Rogers and Calvin Covington. Minnie was born on November 29, 1864, in Mississippi. In 1887, she married Charles Wesley Wadsworth, a military man born in Kentucky on August 6, 1864. Wadsworth was a captain in the US Army during the Spanish-American War. In 1900, he was stationed in Mabalacat of the Philippine Islands. Together, the couple had at least four daughters: Phyla, Leila John, Clover Reata, and Leota Ada. Frequently, the Wadsworth family members visited Ard and Martha Emery in East Tawas, especially during the summer, as indicated by entries in the social columns of the local newspapers. Shown below are Clover (left), Leila (center), and Leota.

Phyla Wadsworth was born to Charles A. and Mary A. Wadsworth on May 27, 1890, in Kansas. During her childhood, she frequently visited her maternal grandparents, Ard and Martha Emery, in East Tawas. Around 1915, she married California real estate broker John "Jack" Selvyn Lineberger. Together, they had four sons: John Wadsworth, James Franklin, Robert Ainsworth, and Richard Covington. Phyla died on May 11, 1973, in Long Beach, California.

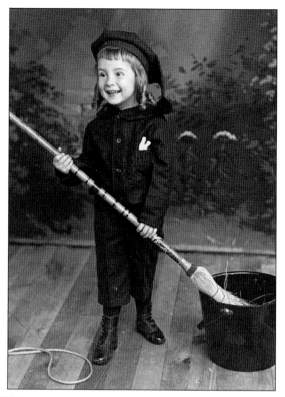

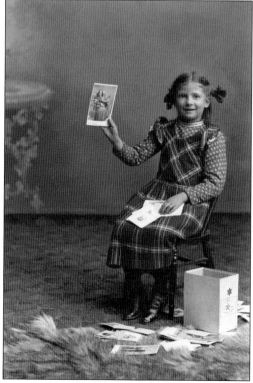

Leila John Wadsworth was born to Charles A. and Mary A. Wadsworth on June 28, 1893, in Claiborne County, Tennessee. In 1900, she resided with her grandparents, Ard and Martha Emery, in East Tawas. Before 1910, the Wadsworth family moved to Brooklyn, Kings County, New York. While there, Leila attended Adelphi College, graduating in 1916. She married Ralph Breiling and died on December 18, 1974, in Windsor County, Vermont.

Photo Studio.

Mr. A. G. Emery, who has had charge of the photo studio at East Tawas for twelve years, has sold the business to Arthur C Hutchinson, of Owosso, one of the best photographers in the state.

Mr. Hutchinson will remain at the studio with Mr. Emery until Nov. 12, when he will take entire charge of it

Mr Emery wishes to announce that he would be pleased to see all his old customers before retiring from the business.

Parties who have had photos made, can have more made from the same negative at a reduced price.

Thanking the people for all past favors and asking for a continuance of the same and assuring you that nothing but high-class work will be done.

We beg to remain.

A. G. Emery.

About Nov. 15, Mr. Emery will sell his household goods at auction. In the meantime call and look the goods over.

Before leaving East Tawas, Ard and Martha sold their household goods at an auction. Their residence on Locke Street was purchased by Charles A. Pinkerton. At age 71, Ard G. Emery moved to Elizabethtown, Tennessee, the hometown community of his wife. His replacement photographer, Arthur Hutchinson, moved into the studio on Newman Street. This front-page advertisement was printed in the *Tawas Herald* on October 14, 1904.

Julia Caroline Emery, the youngest daughter of Temple and Agnes Emery, was born in Peshtigo, Wisconsin, in October 1876. Julia spent much time with Ard, her uncle, whenever her family visited their residence in East Tawas. Because she also was a photographer, several glass negatives in the collection bear her name. She married Harvard graduate and Cleveland educator William Mumford Gregory in June 1904 in Jonesville, Michigan. She died in November 1959.

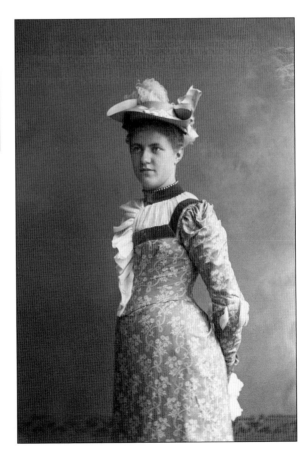

Two

Capturing History through the Viewfinder

Prior to and at the turn of the 20th century, life in Iosco County was a reflection of life throughout the United States. The population was burgeoning, and business was booming. Transportation progressed, which promoted industrial growth and created employment for Americans everywhere.

During his 12-year stay in Iosco County, from 1892 to 1904, photographer Ard G. Emery witnessed the growth, development, and sometimes collapse of many businesses and industrial pursuits in the area, especially in the Tawases. Lumber was milled from harvested timber, salt and gypsum were mined, sugar was produced from regionally grown sugar beets, and a diverse array of businesses thrived and failed.

With a portable studio on the rear of his buggy, Emery frequently traveled to rural and wilderness communities to focus on lifestyles and scenes that no longer exist. He attended photographic conferences in the state to improve his skills and benefit his craft. As the world of photography advanced, so did Ard G. Emery. By using the latest techniques and materials, he refined his artistry and produced high-quality photographs for his customers.

During his residency in Iosco County, Emery was a senior businessman. Traveling the countryside, he carried his cumbersome camera and apparatus, along with many high-tensile-strength photographic glass plates. This could not have been an easy task, but it was one that he seemed to handle with ease and confidence. At times, he was commissioned by businesses and communities to take photographs for promotional campaigns. As a result, he captured the personality and culture of many areas within and around Iosco County.

Today, northeastern Michigan historians and residents can be appreciative for both the photographic genius of Ard G. Emery and the survival of his works. Indeed, the images from Emery's glass-negative collection portray a historic celebration of life in Iosco County from 1892 to 1904.

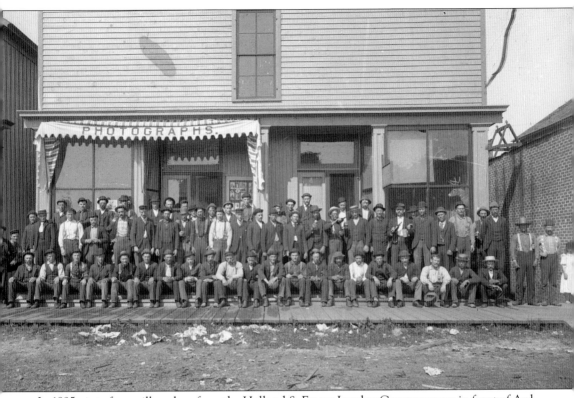

In 1895, sixty-four mill workers from the Holland & Emery Lumber Company pose in front of Ard G. Emery's studio on Newman Street. Some of the men toast the celebration with an alcoholic beverage. For some reason, the sawdust-covered street is littered with trash. Barkman's dry goods store stood to the left of the studio, and the Wonzer Meat Market stood to the right. The office of dentist Dr. Botz shared the first floor with Emery's gallery. Emery's portrait studio occupied the entire second floor of the building. A saloon and dance hall were located across the street.

Ard G. Emery captured this view of Newman Street in East Tawas from the Tawas Bay dock in the late 1890s. The Holland Hotel stands on the left, and the Emery Block, which housed the offices of the Holland & Emery Lumber Company, is on the right. These buildings, plus the Opera House and the Freel Bank Building Block, were considered the anchors of the downtown business district.

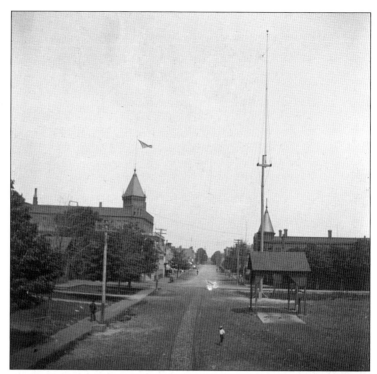

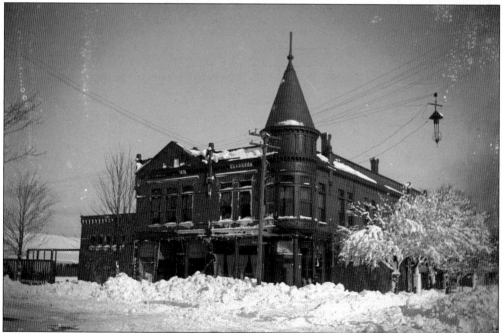

The Emery Block, an impressive brick building on the corner of Newman and Bay Streets, was constructed in 1891–1892. The Sempliner Store, a meat market, and the Emery Company Store were on the first floor. The Holland & Emery Lumber Company offices and public rooms were on the second floor. The building was destroyed by fire in the winter of 1905, when frozen hydrants hampered extinguishing the blaze.

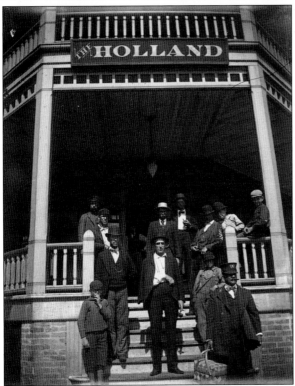

Samuel Anker Sr. was the proprietor of the famous Holland Hotel in East Tawas for many years. He was born in Adelaide, Ontario, on December 18, 1855, and died in East Tawas at the Holland House apartments on December 19, 1917. In May 1882, he married Rose Stickney in Tawas City. They had three children. Before his death, Samuel Anker had lived in East Tawas for 45 years.

Erected in 1893, the Holland Hotel stood at the corner of Bay and Newman Streets in East Tawas. Its elegance, outstanding architecture, and modern offerings made it a showpiece in the state. On two sides of the hotel, three great promenade-piazzas extended the full length. The building underwent several renovations throughout its life and was unfortunately razed in 1989, only a few years before its centennial birthday.

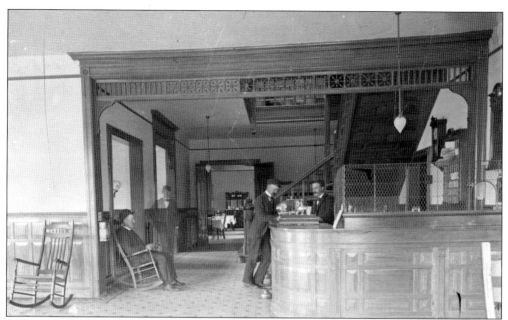

Elaborate ash woodwork and ornate fretwork decorated the lobby of the 80-room Holland Hotel. Located across the street from the railroad depot in East Tawas, this lobby witnessed the arrival and departure of every guest that passed through its doors. The dining room was accessed through the lobby. A ghostly image is seen at left, the result of a man quickly moving out of the range of Emery's apparatus.

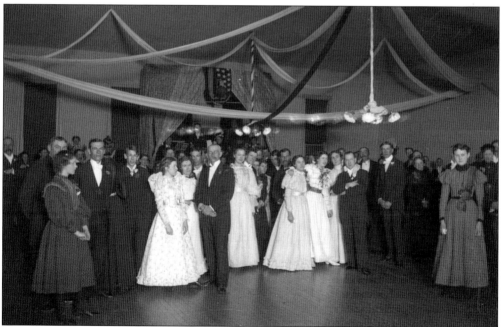

The ballroom of the landmark Holland Hotel in East Tawas was located on the third floor. This large room was a favorite venue for dances, parties, wedding receptions, graduation ceremonies, and other social gatherings. Several electrically lit, well-ventilated, richly decorated guest rooms were also on the third floor. Lovely drapery complimented the windows of each room.

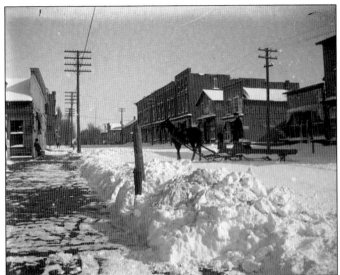

The Opera House Block stood at the southeast corner of State and Newman Streets in East Tawas. Towns that boasted an opera house were considered communities of distinction. Stores fronting Newman Street were owned by individual businessmen, and the opera house meeting room on the second floor was owned by Milo Eastman and Alva Wood Sr. The Opera House Block remained in use until it burned down in the fire of 1926.

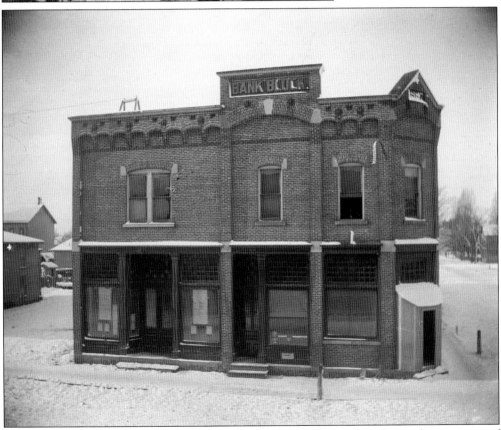

The Freel Bank Building Block, actually two buildings, was located on the southwest corner of State and Newman Streets. The Bank Building faced Newman Street and housed the bank. The second floor served as the telephone exchange for 70 years. The second building, a dry goods and grocery store, was an L-shaped building behind the bank. The buildings burned down on a frigid January 22, 2013, day.

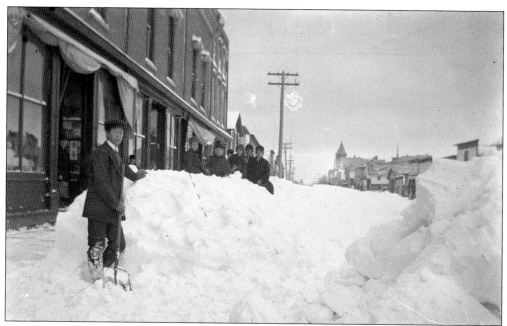

Above, druggist James Edmond Dillon, a longtime resident of East Tawas, clears the snow in front of his drugstore in the Opera House Block of East Tawas. Born in Canada in 1859, Dillon immigrated with his parents to East Tawas in 1870. He married Carrie McMullen in 1881, and they had four children: William E., Ina Mae, Irma Bell, and Charles A. James was first elected clerk, and then supervisor of Baldwin Township. Later, he served as mayor of East Tawas for two terms. He was an active Mason and a member of the Hoffman Lodge of Orangemen. Dillon died in 1927 and was buried in the American Legion Cemetery in East Tawas. In the photograph below, several East Tawas shoppers pose in front of Dillon's drugstore.

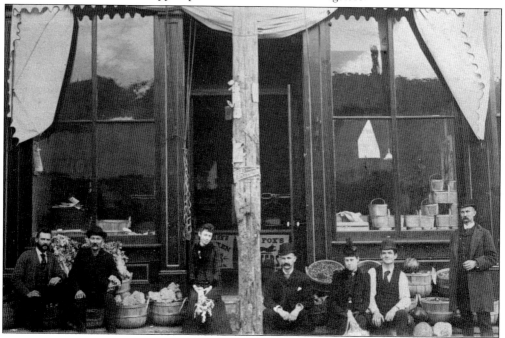

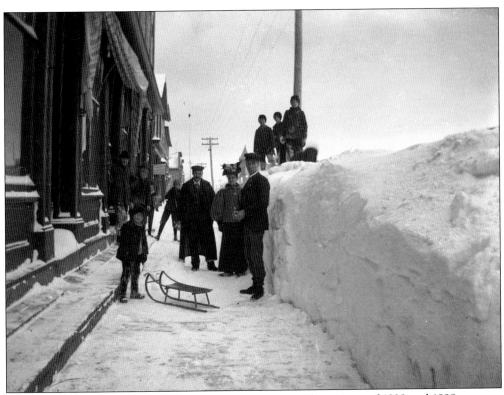

The winters of 1898 and 1899 brought major snowstorms to the communities of Iosco County. Clearing snow was laborious work. Ard Emery was out and about, capturing many memorable scenes from the storm of Christmas Day 1898. This photograph was taken in front of James Dillon's drugstore on Newman Street in East Tawas.

The James R. Snody family poses for Ard Emery's camera. James was the Whittemore postmaster in the late 1890s before moving to the new village of Onaway, where he served as assessor in 1899. He was president of the North East Michigan Development Bureau and sat on the state tax commission. James Snody (left) was married to Ella Mary Armstrong (rear). Together, they had two daughters: Henrietta and Florence.

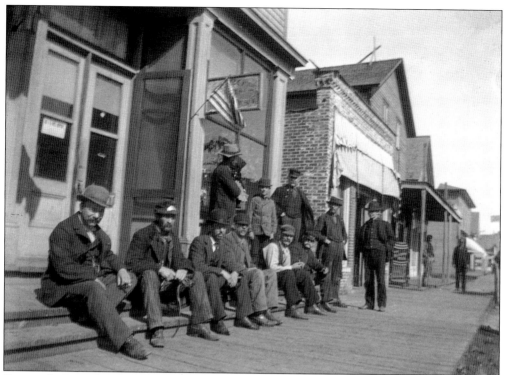

During this era of American culture, the best way to share stories and news of the day was by personal conversation. These men pose in front of the downtown businesses on Newman Street for Ard Emery's photographic apparatus.

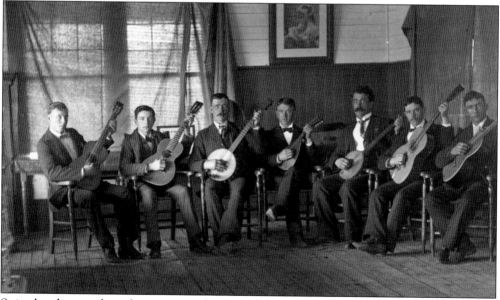

String bands popped up wherever guitar, banjo, and lute players could jam. Bands played for picnics, weddings, and dances. William Lynch (1883–1962), son of Patrick Lynch and Emma Daniels, was a lifelong resident of Clayton Township in Arenac County. His second wife was Isabelle Trombley (1894–1984). Because he ordered this photograph, he is assumed to be pictured.

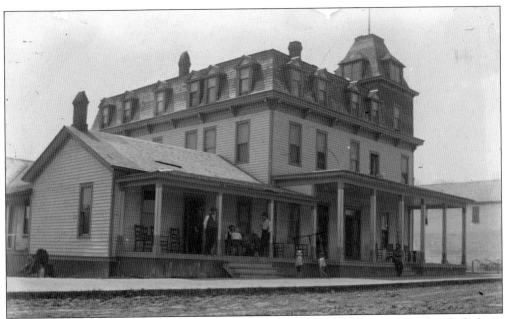

Dotted across the county were numerous hotels and rooming houses used by travelers for lodging and meals. The inns followed rustic roads or rail lines and were usually located near lumber camps. Many inns were stagecoach stops. The larger hotels frequently hosted community activities, parties, and dances. Fire was the fear of every proprietor. Time and again, buildings burned down, and they were often rebuilt. The identity of this particular hotel is unknown.

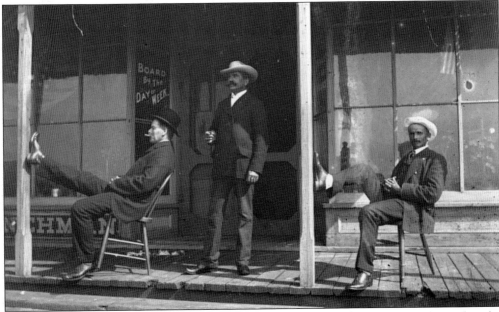

These unidentified travelers enjoy cigars on the porch of the Hinchman House, located at the corner of Bay and Main Streets in East Tawas. Theodore Henry Hinchman, a pharmaceutical supply merchant and Michigan state senator from Detroit, was an early owner of this property from 1874 to the 1890s. In 1904, its proprietor was Thomas Jameson. The building was a grocery store before it was a hotel.

These unidentified men enjoy a brew in front of the Hotel Iosco in East Tawas. This hotel was across the street from the Detroit & Mackinac Railway depot on Bay and Church Streets. The hotel had a large kitchen, dining area, parlor, and rooms for rent. This hotel is not to be confused with the Iosco House of Oscoda.

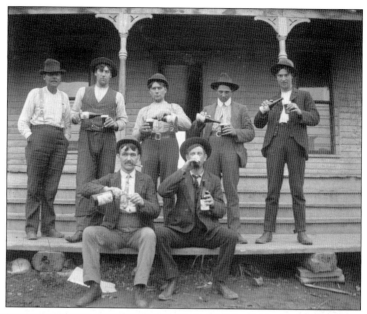

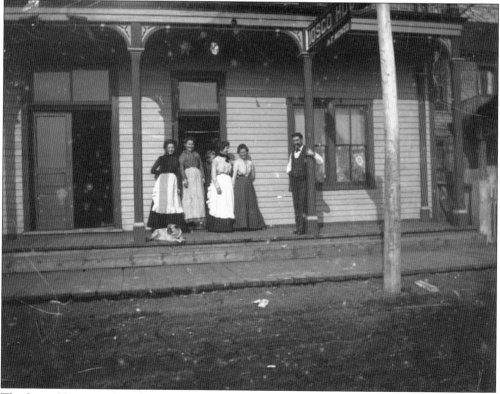

The Iosco House in Oscoda was managed by Albert F. Monzo in the early 1900s. Monzo was born in 1871 in Sanilac County, Michigan. In 1893, he married Alice Blair Labrash in Oscoda. They had two children: Earl and Caroline. After the death of Alice in 1897, Monzo married Emma Herman Ehlert in 1898 in East Tawas. In 1905, he passed away and was buried at AuSable Township Cemetery.

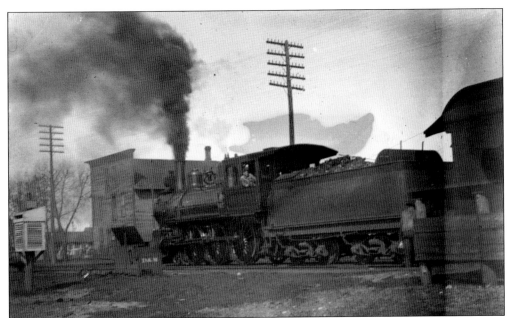

The Detroit & Mackinac Railway Company began in 1878 as the Lake Huron & Southwestern Railway. Lumber baron C.D. Hale built a narrow-gauge line through logging country from the Hale Mill in Tawas City to the East Branch of the Au Gres River. By 1895, the rails expanded and were improved, connecting Alpena to Bay City. Spur tracks connected small towns and lumber camps to the main line.

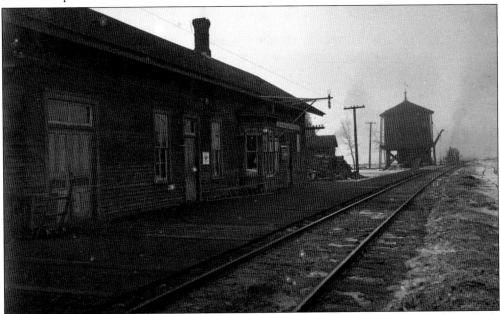

The AuSable-Oscoda train depot was one of the few surviving buildings after the fire of 1911. Trains carried survivors to safety and brought in supplies for those who remained. The railroad had become the predominate mode of transportation for both people and freight by the turn of the 20th century. In election years, as politicians campaigned across the country, the public greeted them at railroad depots.

Industrial narrow-gauge railways were built for specific purposes. During the lumbering era, narrow-gauge spur lines extended from the camps to the main lines and transported logs to the mills. This narrow-gauge line was instrumental during the construction of the sugar factory in East Tawas. Side dump cars moved materials to and from the construction site. Horses were used to pull the cars on the tracks.

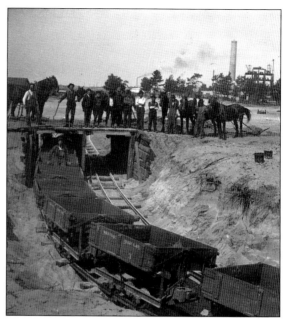

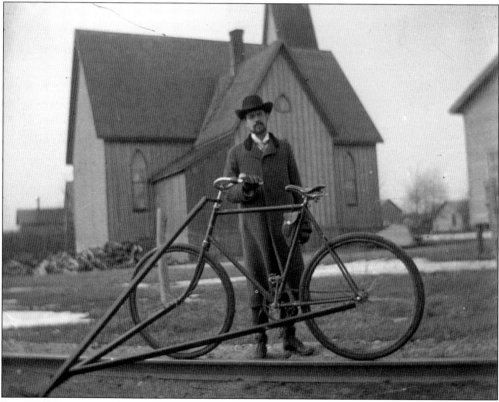

Rev. Will King uses a third-flanged wheel to move his bicycle on the railroad tracks of the Detroit & Mackinac Railway. He commuted between Tawas and Alabaster to deliver his Sunday sermon. Others practiced this travel technique, but after an accident occurred, the railway company ended the practice of private citizens using the rails in this manner.

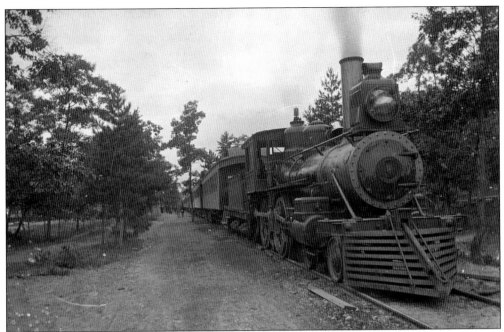

The Tawas Beach Flyer of the Detroit & Mackinaw Railway ran a daily commuter schedule between Tawas and Bay City for businessmen who worked in the Tawas area and lived in Bay City. The railroad company saw the financial potential of creating a beach park on the shores of the Tawas Bay in East Tawas. As a result, Tawas Beach Park was established.

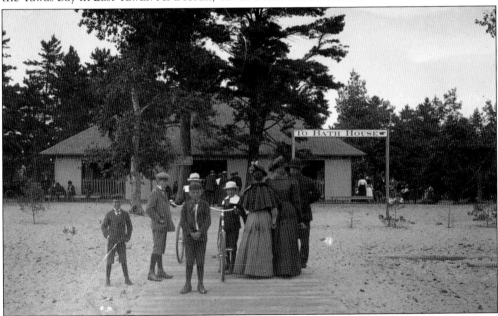

The railroad company purchased 200 acres and developed Tawas Beach Park, building a large pavilion, cottages, a dock for boats, and a bathhouse for swimmers. On Sunday, the excursion trains transported tourists from Bay City and Cheboygan to the recreational area. On one Sunday in June 1896, a total of 1,300 tourists visited the park and enjoyed swimming, fishing, sailing, dancing, baseball, and walks in the woods.

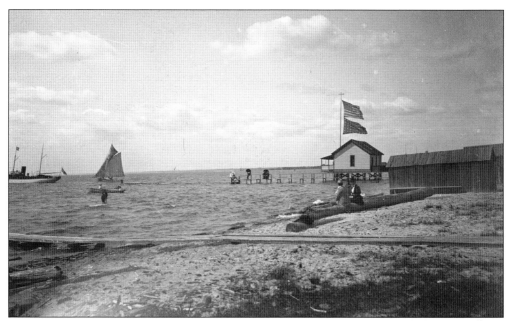

In August 1897, the Detroit & Mackinac Railway Company planned a grand-opening celebration of Tawas Beach Park. Five thousand grocers and butchers from Bay City arrived at the park aboard 50 cars in four trains. The celebration was successful for all, especially the railroad company. Soon, families and fraternal organizations crammed the excursion trains to visit this popular resort area. As a result, the Tawas Bay area developed into a vacation destination.

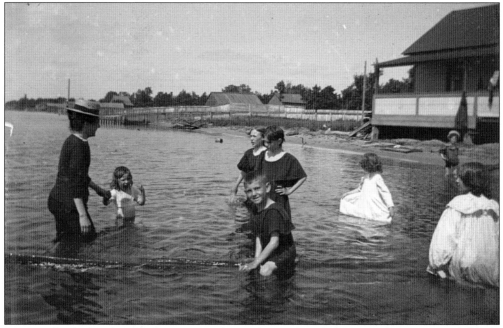

Dressing for the beach around 1900 was a far cry from today's fashions. Ladies wore mostly black, wool, knee-length dresses over black bloomers. These dresses often sported sailor collars. Also, women wore stockings and bathing slippers. Hats were also a must. Boys dressed for the beach in black shirts and knickers, and the girls wore white dresses over bloomers.

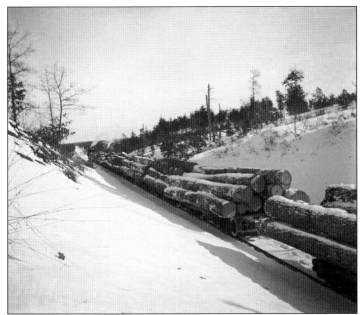

The AuSable & Northwestern Railroad, primarily a logging route, also carried passengers from AuSable to Comins in Oscoda County. It started in 1887 at the Potts Lumber & Salt Company on the Au Sable River in Alcona County. In 1891, the railway was purchased by the Loud Lumber Company. By 1912, the Detroit & Mackinac Railway gained possession and upgraded the rails to standard gauge. The entire branch was abandoned in 1927.

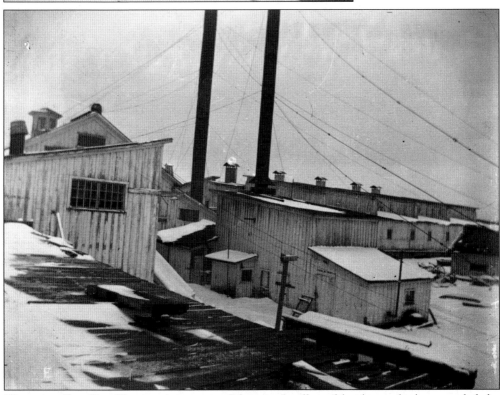

This sawmill in East Tawas was just one of dozens of mills and lumberyards that crowded the Iosco County coast of Lake Huron beginning in the 1850s. Lumber was shipped out by freighter to various parts of the United States and Canada. White pine became king in Iosco County, employing hundreds of men and providing livelihoods for their families. By the late 1890s, the boom was over.

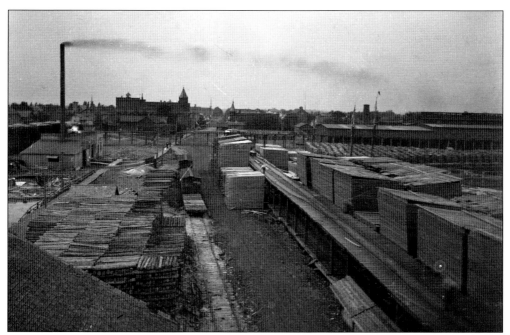

Enormous piles of lumber were stored on the commercial dock in East Tawas during the lumber era. Large sawmills transformed logs into boards, which were used to construct countless buildings throughout the Midwest. From the dock, this view provides a glimpse of Newman Street, with the Holland Hotel on the left and the Emery Block on the right. The electric power plant is on the far left.

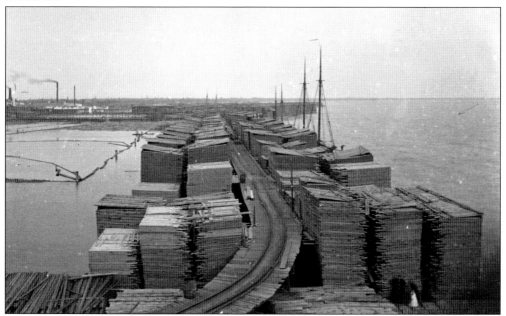

This tramway ran along the Tawas Bay harbor and was used to transport lumber to the schooners for shipment. Note the size of the lumber piles in comparison to the people in this photograph. The Holland & Emery Mill is shown in the upper left. Temple Emery was the only lumberman who did not experience bankruptcy during the 1870s depression.

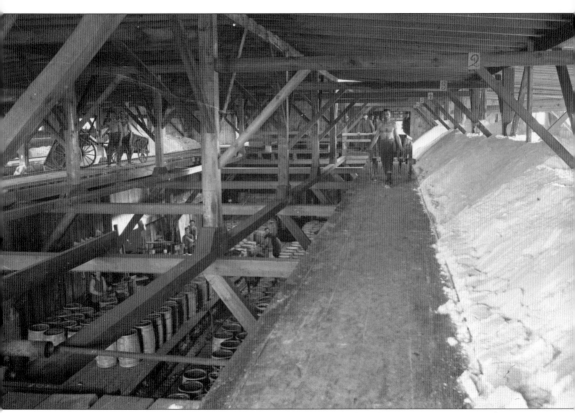

In 1871, the first salt-brine wells in Iosco County were drilled to depths of 800–960 feet by Grant & Son. These wells were later sold to the Emery Brothers Lumber Company, who had also drilled salt-brine wells. Other salt companies were J.L. Wicks, O.S.&L. Company, E.J. Hargrove, Smith Gratwick & Company, Frey & Tebo, Packwoods, and the Iosco Brine Supply & Salt Company. The manufacture of salt from the high-quality brine went hand in hand with preexisting industries. The salt brine was pumped through a wooden pipeline to Oscoda and AuSable to be processed. In later years, the wooden pipeline was replaced with a cast-iron line. Cheap slab wood and wood scraps from the sawmills were used as fuel to evaporate the water from the brine. The dried salt was used as a preservative for the fish industry. Profits began to dwindle due to competition from larger companies, and the local firms slowly went out of business, but not before making their shareholders handsome profits.

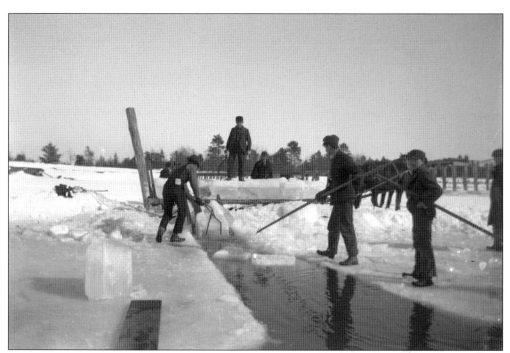

Until the advent of the electric refrigerator, the iceman delivered blocks of ice to homes, restaurants, and hotels. During the winter season, Tawas Bay was a source of ice not only for Iosco County, but for many parts of the United States. Charles "Big Charlie" Curry had a contract with Swift & Company of Chicago for 1,000 railroad cars of ice per year. In addition, 100 railroad cars filled with ice were sent to Detroit. Many of these ice companies also sold coal, which heated homes in winter. Nearly 300 men were employed to cut ice on the bay. Harvested ice was covered with sawdust and stored in icehouses for use during the warm-weather months. Welcome treats for kids on a hot summer day were the bite-size chunks that fell from the ice wagon during delivery.

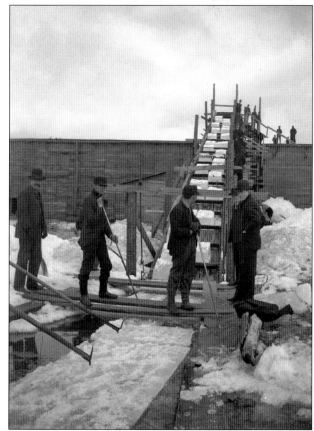

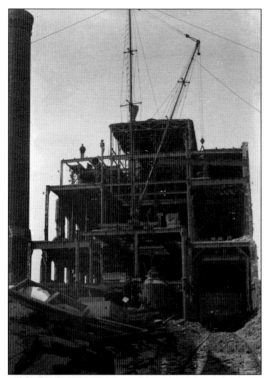

After the lumber industry dwindled in Iosco County, agricultural pursuits commenced. It was hoped that the construction of the Tawas Sugar Company in 1902, the largest factory to be built in the Tawases, would lead to prosperity for area farmers and capitalists. Kilby Manufacturing Company of New York and W.J. Spear of Toledo, Ohio, were the contractors of this $700,000 project. This huge steel-and-brick building was erected on what is now the corner of US 23 and Tawas Beach Road. The Detroit & Mackinac Railway built a track to the factory to bring in construction materials, carry limestone from Alpena, and eventually to transport processed sugar. The factory had the capacity to process 500 tons of beets per day. Construction provided jobs for over 100 laborers in the Tawas area. Ard Emery captured many images of the plant during its construction.

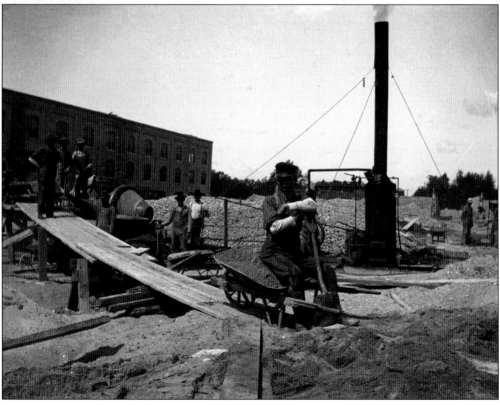

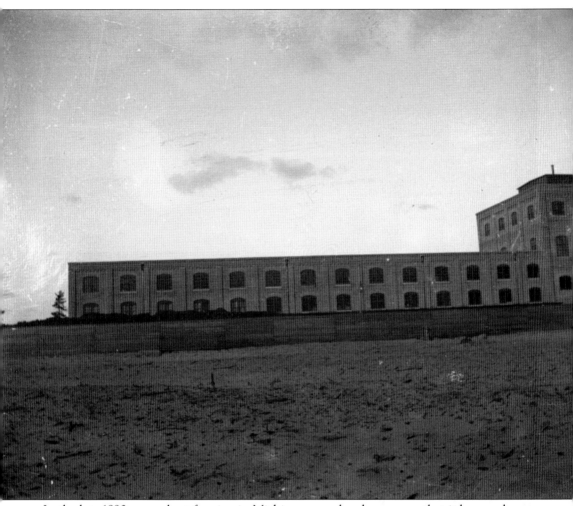

In the late 1890s, sugar beet farming in Michigan proved such a success that it became known as the mortgage payer. Seeing this as a great investment, the Tawas Businessmen's Association began promoting the construction of a sugar-processing plant in Iosco County. In 1902, the construction of the Tawas Sugar Company's plant began. Sadly, processing sugar beets did not prove as successful in the Tawases as it was in Bay City. Many factors led to the demise of the sugar-processing industry in Iosco County. Poor growing seasons and conditions, along with inexperience for cultivating sugar beets, were some of the major reasons for failure. Growing and harvesting sugar beets was too labor-intensive for area family farms. Also, poor roadway conditions made it difficult to transport the beets to the plant with a horse-pulled wagon. In 1905, after three growing seasons, the company notified farmers that the factory would close and that their sugar beets could be shipped to Bay City. The property was sold, the building was torn down, and the processing equipment was shipped to other plants.

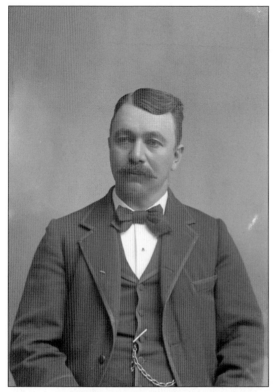

Ambrose S. Schill, at left, manufactured cigars in East Tawas for 30 years. Originally, his business was located on East State Street, which later became the location of the *Iosco County Gazette*. Below, Schill poses with his two children, Reuel Ellsworth and Alvah, in front of the business. Later, he moved his company to the corner of Bay and Newman Streets. His cigars, labeled "D&M," were sold along the Detroit & Mackinac Railway. The cigar business had become very competitive before 1900, yet Ambrose Schill continued his business until his death. Born on August 9, 1851, in Canada to John Schill and Sarah Bernhartd, he died on January 31, 1914, in East Tawas from complications of the liver. He married Sarah Jane Furtney on May 16, 1883, in Oxford County, Ontario.

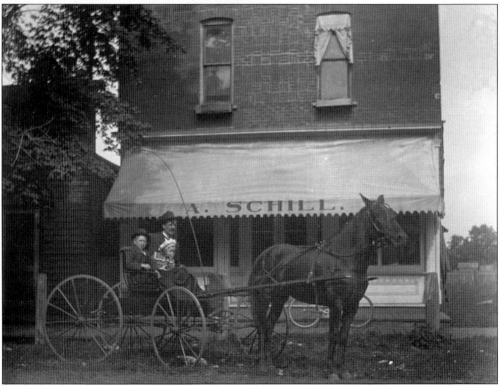

Loren Henry "Lawrence" Klenow, a farmer from Baldwin Township, married Julia Topa, a housekeeper also from Baldwin Township, on May 1, 1899, in East Tawas. He was 22 years of age, and she was 19. Witnesses for the couple were John Klinger and Rose Topa, both from Baldwin Township. When Lawrence Klenow registered for the draft in World War I, he listed his occupation as a self-employed grocer.

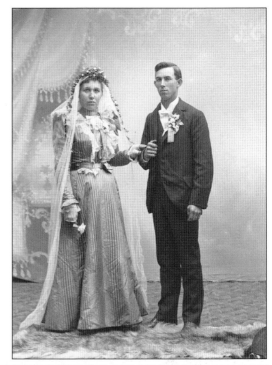

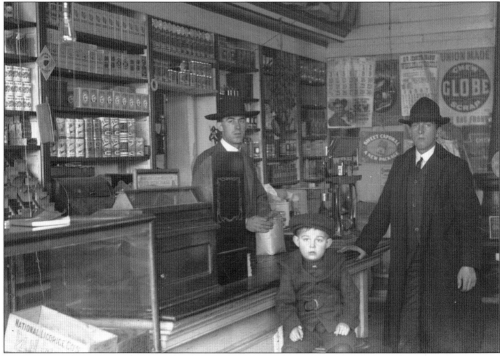

Loren H. Klenow (left) opened the original Klenow's Grocery at 201 Newman Street in East Tawas in April 1900. As in the early days of the store, the meat counter is today one of the best in town, filled with fresh steaks, homemade sausages, and well-seasoned smoked meats. For well over a century, the Klenow family has served the East Tawas community.

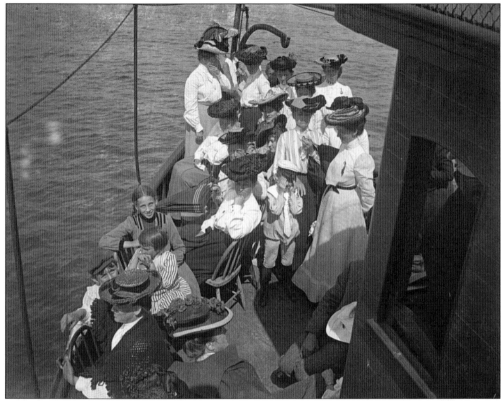

Enjoying a Sunday picnic aboard a boat harbored in Tawas Bay was a frequent pastime for families. The ladies and girls in the photograph above are on the ship *Baltimore*. The steam freighter was caught in a severe storm and sank in the Fish Point area of AuSable on May 24, 1901. She had made it to Thunder Bay near Alpena when strong winds forced her to turn south toward Tawas Bay. As a result, 13 members of the 15-man crew drowned, including the captain, M.H. Place, and his wife. The second engineer, Mr. Murphy, and deckhand George A. McGinnis were rescued. The storm was one of the most severe in the area. Below, a picnic group poses for Ard Emery's camera aboard *Alvina*, a schooner owned by Edwin Alonzo Farrand. Shown in the near front of this photograph is Emery's wife, Martha (left of center).

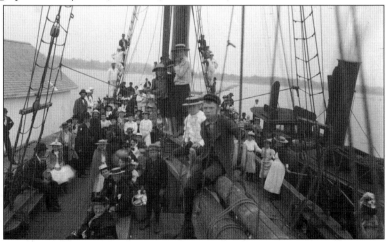

The schooner *Bertha* is anchored at the East Tawas commercial dock in 1895. She appears to have a flat bottom, which indicates that she was a scow, simple in design and cheaper to make. Her shape enabled her to navigate the poorer and shallower ports on the Great Lakes, carrying lumber, sand, hay, and other commodities. Boats of this design were not fast, but they got the job done.

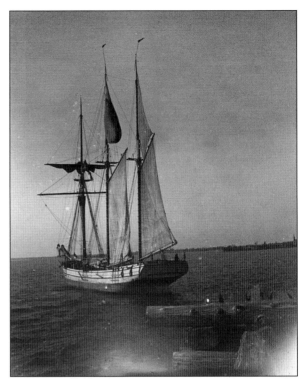

Commercial fisherman Joseph Lixey earned his living at the mouth of the Au Sable River during the 1860s. His son Joseph joined him in 1887, and the family fishing company eventually moved to East Tawas. Here, folks enjoy the Independence Day celebration on Tawas Bay aboard the Lixey boat *Fleetwing*.

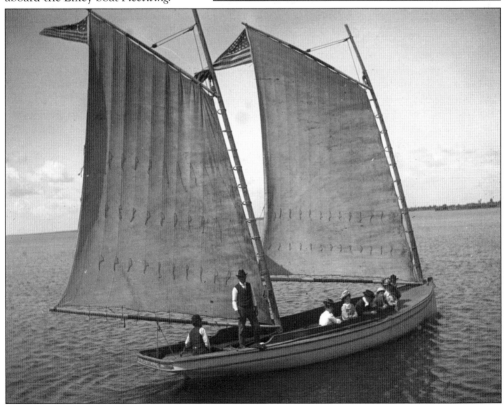

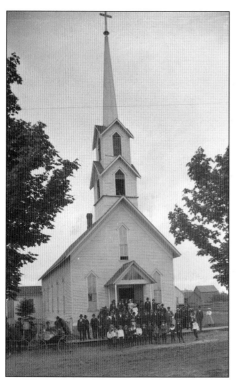

Swedish immigrants organized the Abigail Evangelical Lutheran Church in 1886. It was built for $1,000 and located at the east end of State Street in East Tawas. Initially, 70 adults and 69 children were members. The name was changed to Grace Evangelical Lutheran Church in 1939. In the 1950s, land was purchased on the corner of Main and Lincoln Streets in East Tawas, and a new church building was completed in 1956.

Zion Lutheran Church was organized in 1870 and stood at the corner of Church and Newman Streets in East Tawas. Because many of its members were farmers, the congregation decided to erect a new church and school closer to their homes on Plank Road. Pictured here are the church and parsonage built on Second Street in Tawas City in 1890. A new school was dedicated in 1896.

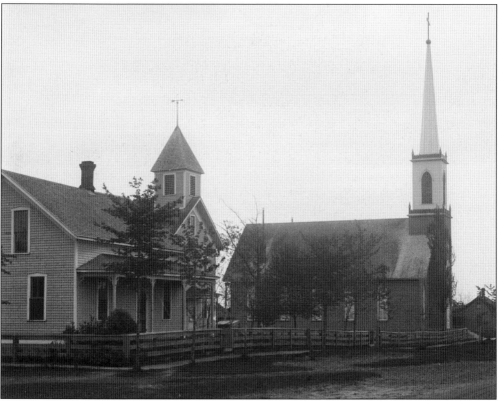

The Iosco County Courthouse in Tawas City was the center of local government from 1869 to 1954. In 1866, Gideon O. Whittemore, Tawas Township supervisor, attempted to locate the county courthouse in the upper floor of his house, but the idea failed with the board of supervisors. After three countywide referendums, construction was approved, and this building was completed in 1869. In 1954, a new county building replaced this structure.

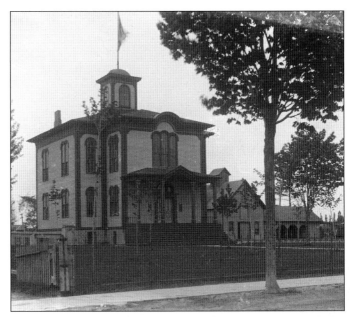

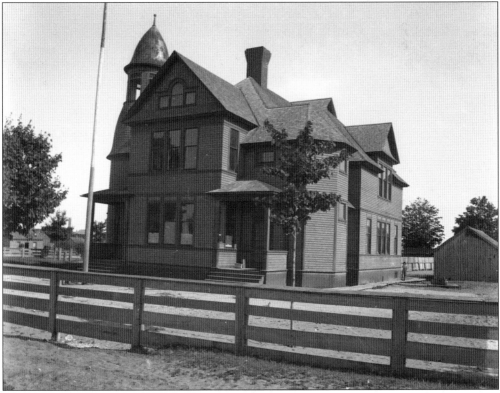

Tawas City School (pictured) was built in 1868 on the outskirts of the city at the corner of Eighth Avenue and Second Street. It had two wings, two floors, and a belfry. In 1892, fire destroyed this building. A new school was built, which soon became overcrowded. Additions to the building accommodated more students and the Iosco County Normal, which thrived from 1905 until 1920.

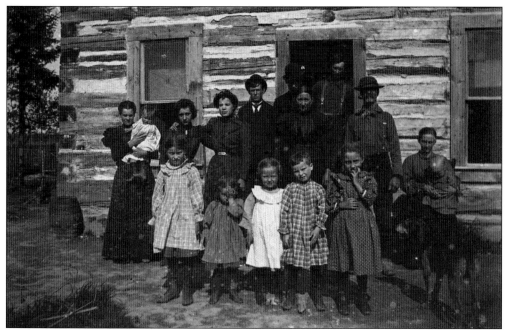

Early settlers of Iosco County used logs to construct their homes. The chimney was made of stones, sticks, and mud. Cracks between the logs were chinked with sticks and plastered over with clay mud. The first floor provided space for the kitchen, dining and living areas, and sometimes a bedroom. A ladder led to additional sleeping areas above the first floor if needed.

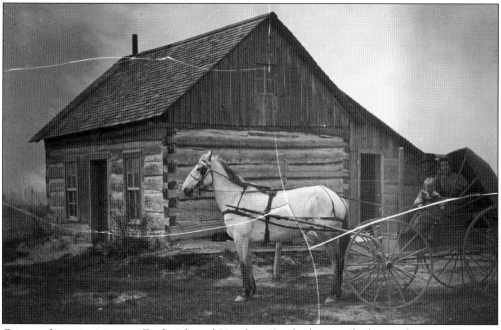

German-born immigrants Frederick and Karolina Gaul, along with their infant son Herman, settled in East Tawas in the early 1870s. Eventually, five more children joined the family: Theodore Johann, Maria, Emma, Frederick Jr., and Johanna. The 160-acre Gaul farm was located on Hemlock Road. Frederick's brother Otto also settled in East Tawas and later moved to Chicago.

The retirement home of Sheriff Peter Shien overlooked Tawas Bay. Shien was born in February 1848 in Almira, New York, and moved to Michigan in 1852. He enlisted in the Army of the Potomac at age 15 and mustered out in 1865. Returning to Michigan, he became a timber estimator for the logging companies in Oscoda. In 1895, he won a hard-fought election for Iosco County sheriff. He died in 1926.

Nels Johnson, a prosperous, well-dressed farmer from Baldwin Township, was born in September 1862 in Sweden. He immigrated with his parents about 1884 and married Segrid Nelson in 1886. They had at least nine children. The Iosco County War Board had a rather strong opinion of his character in 1918, when he refused to buy any of the Fourth Liberty Bonds.

47

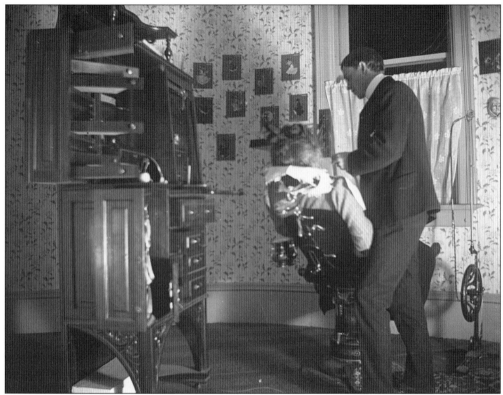

The dentist office of Dr. John H. Botz was located next door to the Emery Photo Studio on Newman Street as early as 1891. Botz was an 1889 graduate of Philadelphia Dental College and Hospital of Oral Surgery. He married Cecilia Priscilla Price of Whittemore in 1891. He sold his practice to Dr. C.F. Klump of Detroit in 1910. Dr. Botz died in Maryland in 1933.

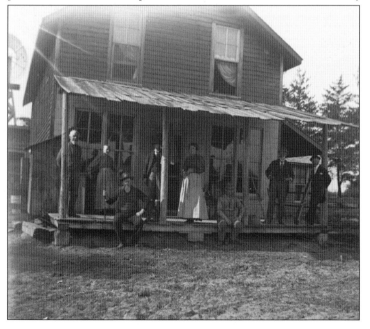

The country general store served as the social hub for purchasing supplies and provisions, for sending and receiving mail, and for gathering and sharing local news. These rural stores were built by the lumber mill owners near their mills. As roads improved, many of these stores disappeared from the landscape, but a few remained into the 1950s. This store was located near Silver Creek in Wilber Township.

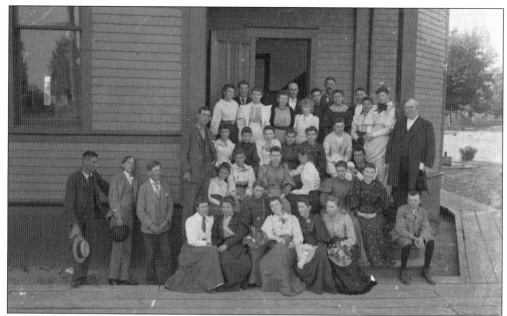

The Presbyterian congregation poses in front of their church with their beloved minister, Alexander C. Kay (standing, far right). Reverend Kay organized the Presbyterian Society in East Tawas in 1869. Their church was located on Lincoln and Smith Streets. The society dissolved in 1933 due to low membership. Kay served as minister from 1886 until 1905, when poor health forced him to retire.

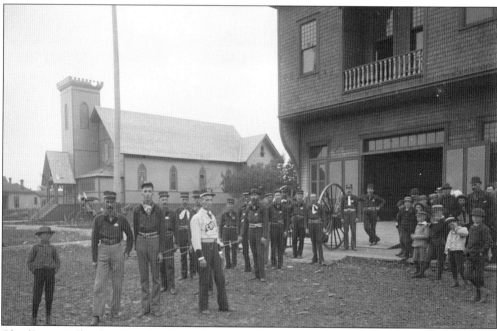

Chief James Dillon (in white shirt) and the crew of the East Tawas Volunteer Fire Department stand in front of the old fire barn for a photograph. Note the hose cart in the background. The volunteer department was formed in 1887, when the bucket brigade was the major way of fighting a blaze. Tawas City finally organized a fire department in July 1895 after several unsuccessful attempts.

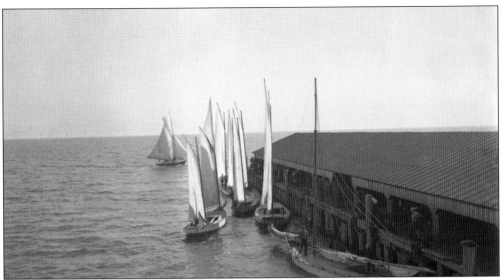

Visiting yachtsmen to Tawas Bay encouraged local boaters to plan a race. With the support of the Detroit & Mackinac Railway, the races became reality in early September 1897. Excursion trains brought spectators from Bay City, Saginaw, and Alpena to enjoy the event. Yachts were moored at the East Tawas dock prior to race time in this photograph.

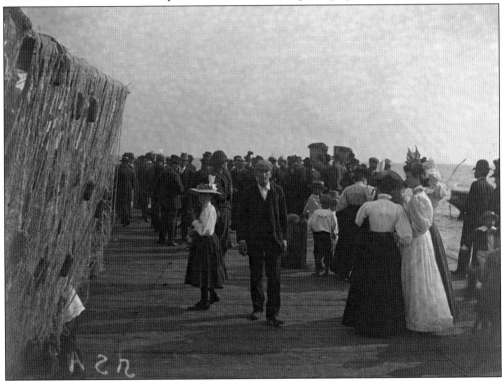

As fishnets dry in the summer sun, visitors stroll on the boardwalk at the Tawas Bay dock. The exact date and occasion of this photograph are not known. Excursion trains brought hundreds of visitors to the Tawas area every Sunday throughout the year. The area benefited handsomely from tourism in the 1890s.

The bicycle craze of the 1890s greatly influenced social and recreational life in Iosco County. Cycling clubs were organized, bike paths were built, and bicyclists of all ages enjoyed the activity. The Tawas Cycling Club was organized in June 1896. The club's colors, maroon and cerise, were chosen by the female members of the club. Riding rules were established to ensure safety during the rides. Passenger trains were also affected by the advent of the bicycle. In 1896, crates were built on railcars to transport bicycles in advance of a law dictating that bikes be carried as free baggage. The Tawas Cycling Club was responsible for developing a bike path to Ottawas Point (now Tawas Point) and for the improvement of roadways in the area. Below, sisters Louise (center) and Stella Oakes (right) enjoy biking on the commercial dock in East Tawas with a friend.

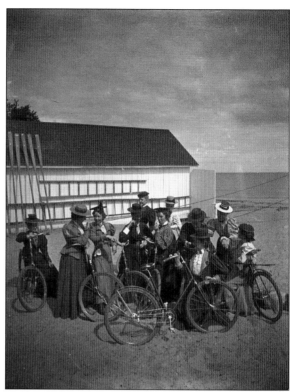

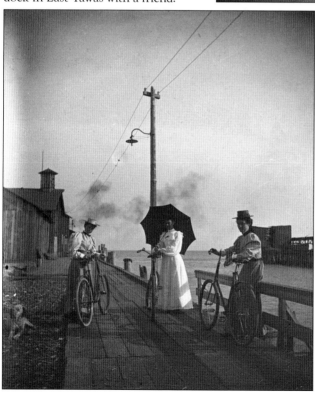

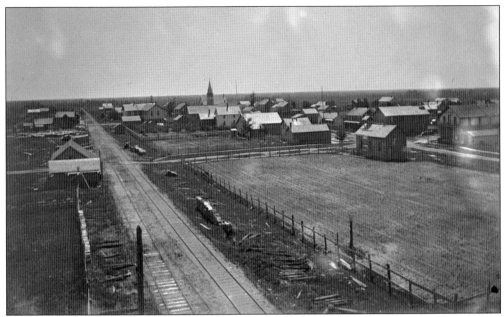

In 1879, Whittemore became a railroad station along the Detroit–Bay City–Alpena mainline. By 1899, when this photograph was taken from atop the gristmill, the settlement was surrounded by countless lumber operations. After the trees were harvested, many people began to cultivate the fertile soil of Burleigh Township, and the population of the area blossomed. Whittemore was incorporated as a city in 1907.

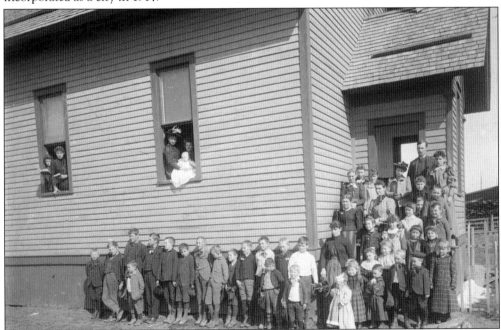

In the 1890s, the settlement of Prescott in Richland Township of Ogemaw County was a lumber boomtown. Shown here in the early 1890s is the first schoolhouse built in Prescott. This two-room building was located on Sherman Street. Even with the large facility, the first-grade and kindergarten classes were held across the street in the Odd Fellows Hall due to lack of space.

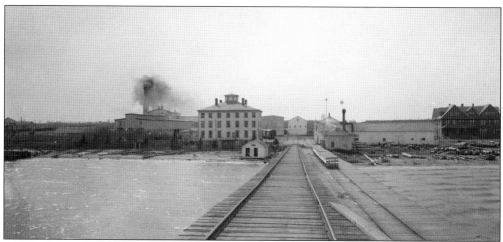

Gypsum was known to exist in Alabaster as early as 1837, but it was not until 1862, when Benjamin F. Smith acquired the property, that the quarry was opened. Alabaster gypsum was shipped out by boat or train to processing plants. The Alabaster Mine supplied material for the main buildings at the Chicago World's Fair in 1893. The photograph above shows the buildings of Western Plaster Works from the dock. The three-story structure on the left was the company office and store, with living quarters on the upper floor. The Cadillac Hotel was located across the street. Gypsum miners loaded the rock onto railroad dump cars to be transported to plants, where it was processed and used in plaster, powders, and paint. Later, the gypsum was utilized to manufacture wallboard.

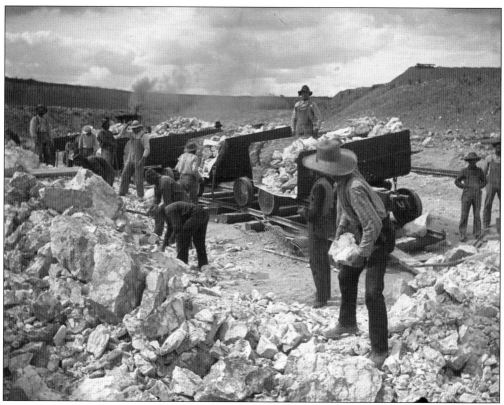

Barnhart "Barney" Blust purchased seed oats, rye, and barley that were known as "Champions of Russia." Oats grew six feet tall, and the rye and barley were of equal quality. He exhibited this grain at the 1903 Michigan State Fair. Barney was born in 1859 in Germany and immigrated to America in 1872 with his parents. The Blust farm was located on Meadow Road west of Tawas City.

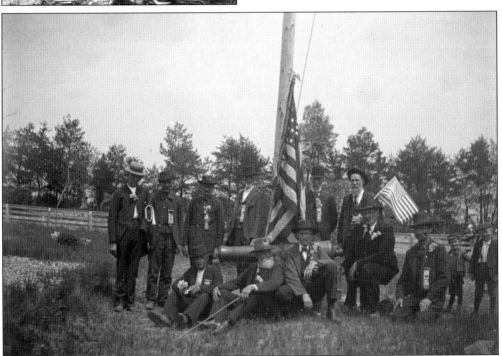

The Grand Army of the Republic was the fraternal organization for Civil War veterans of the Union army. The Iosco County post was organized in July 1882 and named after G.K. Warren. Reuben Wade, the last commander of the post and the last surviving member of this organization in Michigan, stands second from left. The men are posing with the cannon in the military cemetery in East Tawas.

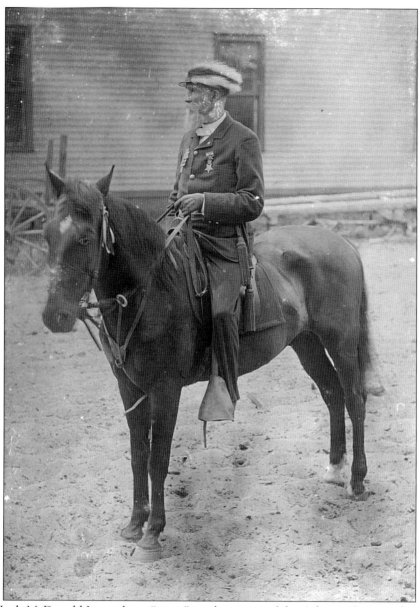

Capt. Hugh McDonald Jr. was born "at sea" on the waters of the Atlantic Ocean as his parents immigrated to America from Scotland in 1831. Upon arriving in New York, his father, also named Hugh, joined the US Army and died while serving his new country. Courageously, as a young lad, Hugh followed in the military footsteps of his father. In 1847, McDonald served as part of Garland's Brigade during the Mexican War and was severely wounded at the Battle of Molino del Rey on September 8, 1847. Following this military endeavor, he moved to Ithaca, New York, and married Frances Taber on October 18, 1849. After the outbreak of the Civil War, McDonald organized Company G of the 42nd Pennsylvania Volunteers, which became known as the "Pennsylvania Bucktails." Note that his hat is adorned with the tail of a whitetail buck. Around 1869, Capt. Hugh McDonald and his wife moved to East Tawas, where their daughter, Mrs. Albert French, resided. Captain McDonald died in East Tawas on July 29, 1894, and was interred at the military cemetery.

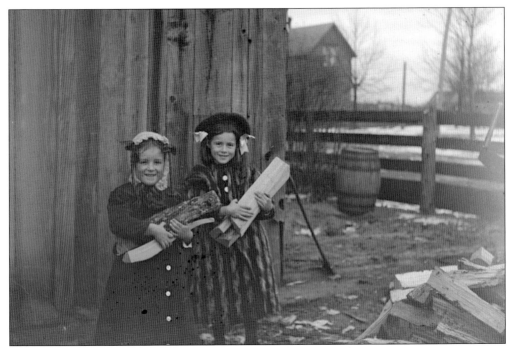

Duncan Boomer was born in August 1872 in Michigan. He married Helen Melvina Falls in 1894 at Lewiston, Montmorency County. Their union produced four daughters: Maria (born 1895), Doris (born 1897), Hazel (born 1899), and Lois Helen (born 1901). The Boomer family resided in Alabaster and East Tawas for many years. Eventually, Duncan and his family moved to Flint, where he worked as a butcher and later for Buick Motor Company. Maria worked for the *Iosco County Gazette* and became a teacher in Wolverine. She married George Norton in 1917. Doris, a teacher in Alabaster, married Ward Pilley of Flint in 1923. Hazel was a teacher in Otisville, and she married Chris Rank in 1924. Lois Helen married Dennis McCormack of the Coast Guard Station at Tawas Point in 1919. It is uncertain which Boomer girls seen above are carrying wood. Pictured below are, from left to right, Doris, Lois, Maria, and Hazel.

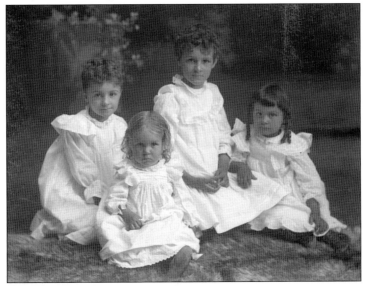

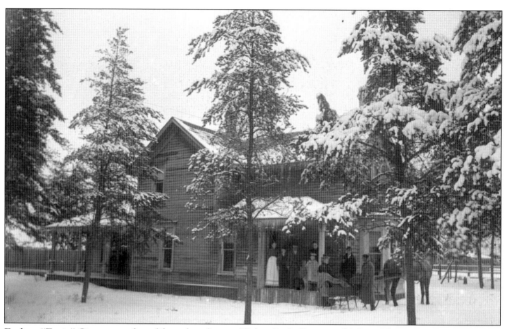

Esther "Essie" Sims was the oldest daughter of John Jack Sims and Mary Elisa Eaton. Essie, born in March 1886, never married, and she lived her entire life in the East Tawas area. Her father was a hunter and trapper. Essie died in June 1972 and was interred at Greenwood Cemetery in East Tawas in the family plot. Shown here is her residence in East Tawas.

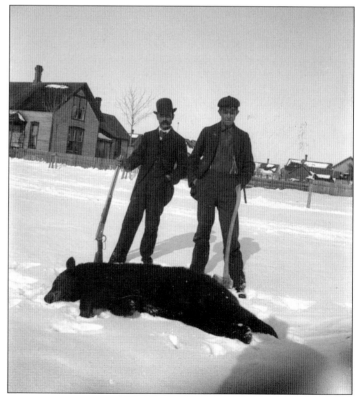

The Michigan black bear population in Iosco County was significantly greater around 1900 than it is today. In 1905, while cutting wood, this black bear surprised William Sims of East Tawas. To protect himself, he killed the bear with his poleax. Williams stands on the right, and Jack Sims stands next to him, holding his rifle, which had no part in the kill. William and Jack were older brothers of Essie Sims. Both men never married.

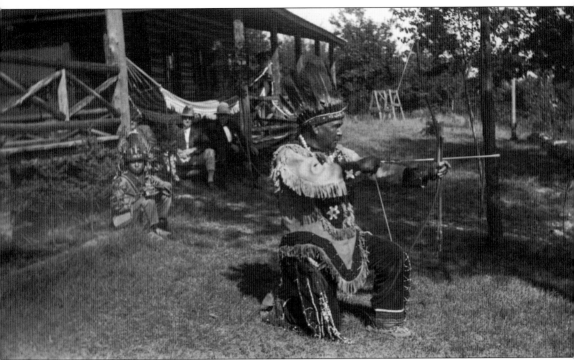

Chief Sodney Mucklepush (Mukkukoosh) Adams was a direct descendent of a long line of Chippewa chiefs. His name has countless spelling variations. Sodney was raised by his maternal grandmother, hence the Adams name. His birth date has been calculated to be about 1849. From Shiawassee County, he moved to Iosco County and joined his "father," John Tad-gwo-sung, a preacher known as Indian John. They lived together on Dease and Long Lakes. Sodney married and had a daughter, Elisa. Elisa's two sons, Otto and Louie, were raised by Sodney after she and her husband died. The chief was known throughout the community for his beaded suits and moccasins, which he wore in regal fashion. Sodney Adams participated in parades and festivals, wearing his headdress and demonstrating his skill with the bow and arrow. Gov. Fred Warner recognized him as the chief of the Chippewa tribe at a 1908 Fourth of July gathering on Long Lake. Chief Sodney died on November 3, 1929, and was interred in Esmond Evergreen Cemetery in Hale.

Three

FOCUSING ON PORTRAITS IN THE STUDIO

Photography during the lifetime of Ard G. Emery advanced and progressed as speedily as the world around him. When not traveling with his portable studio to local communities, he captured the look and demeanor of customers in his classic-Kodak studio in East Tawas.

Interest in photography heightened after the development of the glass-plate negative. Do-it-yourself manuals assisted both amateur and professional photographers. It is safe to assume that Emery was both a self-taught and self-made photographer. In turn, he inspired the photographic talents of his adopted son, Charles, his niece Julia Emery, and his nephew James T. Emery, who all became ardent photographers.

Emery's second-story studio on Newman Street in East Tawas was similar to studios he had kept in Ishpeming and Marquette, Michigan, and Junction City, Kansas. Glass skylights installed in the roof and windows on the north-facing wall allowed as much natural light as possible into the studio. This light was regulated by a series of blinds and curtains. An assortment of backdrops was available for each sitting, as well as an array of chairs and props. The darkroom was probably located in the rear of the building, most likely upstairs, and that was where the glass plates were developed and photographic prints created. Ard Emery utilized prepared dry glass-plate negatives throughout most of his career in East Tawas. Because his studio was a classic-Kodak facility, he undoubtedly purchased supplies directly from Kodak.

At the end of the 19th century, when black-and-white photography became increasingly popular, several thousand customers passed through the door of Emery's studio in East Tawas. While most customers dressed up for the occasion, others were photographed in their working attire. Babies, children, families, community leaders, and even pets and funeral floral arrangements were subjects for Emery's photographic talents. Not only did he capture the images of countless individuals, but he also preserved the personality of a community, as well as the essence of an era gone by.

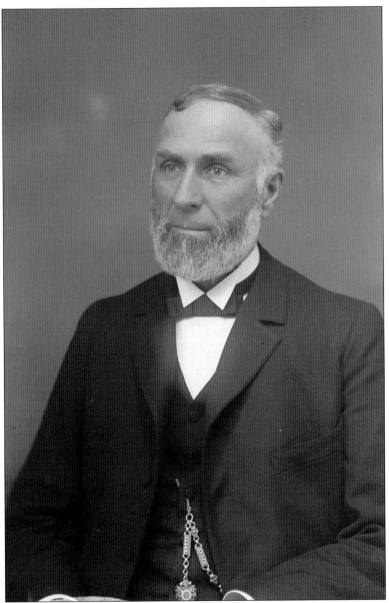

Temple Emery was one of five sons born to Temple Hosea Emery and Diana Godfrey. He was born on July 5, 1837, in Bradley, Penobscot County, Maine. Temple was a younger brother to photographer Ard G. Emery. At 20 years of age, Temple Emery moved to Peshtigo, Wisconsin, and was there in 1871 when that lumber town was entirely destroyed by fire. In 1872, he followed the lumber industry to Bay City, Michigan, and later to Alpena. In March 1877, he operated a sawmill in East Tawas with his brother Hiram. Eventually, the Emery Brothers firm dissolved, and the Holland & Emery Lumber Company was formed. In 1901, Temple was appointed as congressman to succeed R.O. Crump. His magnetism and sterling character garnered him widespread support. Well known as an excellent businessman, he was also respected in political circles. On October 13, 1913, at the age of 76, Temple Emery died at the Masonic Home in Alma, Gratiot County, Michigan following a brief illness. His body was laid to rest beside his wife at Elm Lawn Cemetery in Bay City.

Elizabeth Agnes Ogden was born in Delhi, Delaware County, New York, in May 1843. In May 1860, she married Temple Emery in Oconto County, Wisconsin. Together, they had four children: William Ogden, Cora Ann, Temple Jr., and Julia. Elizabeth Emery died at the home of her daughter, Cora Bigwood, in Toronto, Ontario, on December 26, 1904, at age 61. She rests peacefully at Elm Lawn Cemetery in Bay City.

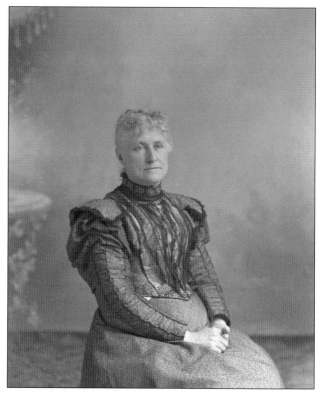

William "Will" Ogden Emery, the eldest child of Temple and Elizabeth Emery, was born in Peshtigo, Wisconsin, in October 1862. In November 1890, he married May Cornelia Bishop in Chicago. After working as bookkeeper for his father's business in East Tawas, he moved his family to Detroit and worked for a chemical and dye factory. He died at age 78 and was interred in the family plot in Bay City.

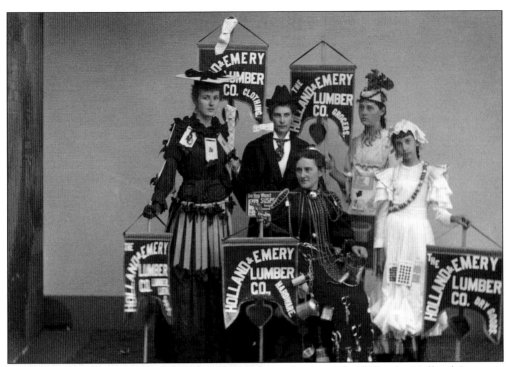

In the early 1890s, the Holland & Emery Lumber Company vitalized the East Tawas economy by constructing a large lumber mill that employed over 200 workmen. At the same time, the company built the famous Holland Hotel and a large, two-story brick general mercantile on the corner of Bay and Newman Streets in East Tawas. This photograph was taken during the grand-opening celebration of the Holland Hotel in May 1893.

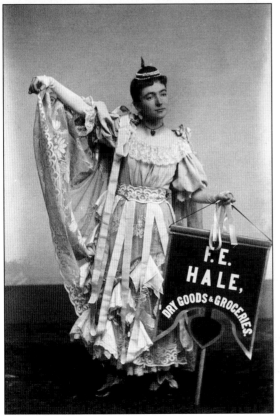

Born on March 26, 1881, in East Saginaw, Lizzie McLean was the daughter of John B. and Ellen McLean, residents of East Tawas in the 1890s. In this photograph, Lizzie proudly displays an advertisement for her husband, F. Eugene Hale, a dry goods and grocery merchant. The couple was married on November 25, 1896, in East Tawas. Lizzie died in February 1908 in Caledonia, Kent County, four years after her husband's death.

Emma Gates was born on October 18, 1863, in Chagrin Falls, Cuyahoga County, Ohio. On January 16, 1881, she married Alston Swayze at Niagara Falls, New York, and they moved to Iosco County about 1890. The couple divorced in August 1896. Emma married jeweler Luther L. Johnson in March 1904, and that marriage ended in 1924. Emma Gates Swayze was a milliner and owned a shop in East Tawas. Both girls seen here modeling for Mrs. Swayze's shop are unidentified.

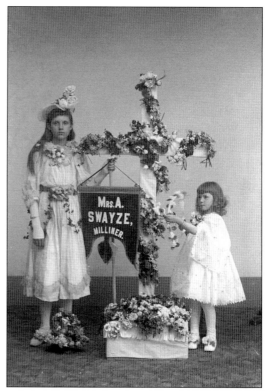

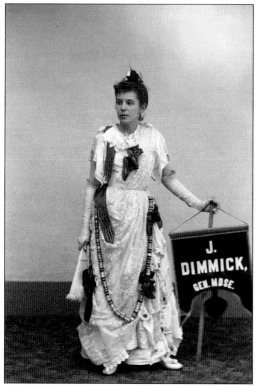

Joseph G. Dimmick was a businessman and highly esteemed citizen of Iosco County. Born in Detroit in 1867, he came to East Tawas at the age of three, when his father established a general merchandise business. Joseph served as county treasurer, city clerk, and road commissioner. He died in July 1941 and was survived by his wife, Lillian, and son Thomas Burdon. Here, an unidentified girl advertises for Dimmick's store.

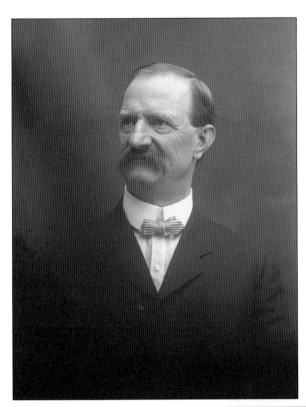

Charles Rowe Jackson was born in December 1853 in Shiawassee County. At age 11, he apprenticed at the *Shiawassee Tribune*, and by age 16 he was a master printer. In January 1877, he came to Tawas City, purchased the newspaper, and moved it to East Tawas. He was the editor of the *Iosco County Gazette* for over 50 years before ill health forced him to retire. He died on April 22, 1935, in East Tawas.

William B. Kelly was born on November 14, 1844, in Ireland. In 1870, he married Agnes Smith, who was born on March 22, 1838, in Kingston, Ontario. The couple had one daughter, Jennie. William Kelley served as postmaster of Tawas City from April 29, 1897, until his death on December 15, 1912, at age 68. William and Agnes Kelley were buried at Memory Gardens Cemetery in Tawas City.

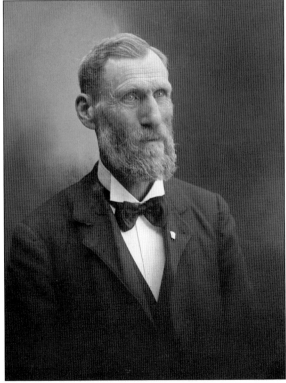

Phineas Smith, born in Pennsylvania in September 1832, was a resident of East Tawas for nearly 45 years before his death on June 4, 1915. He held the offices of city treasurer and city marshal for many years. His wife, Annie Elizabeth Schuyler, preceded him in death by 20 years. Phineas and Anne E. Smith were interred at Greenwood Cemetery in East Tawas.

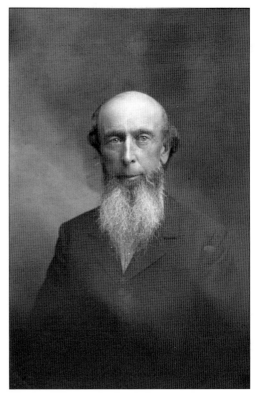

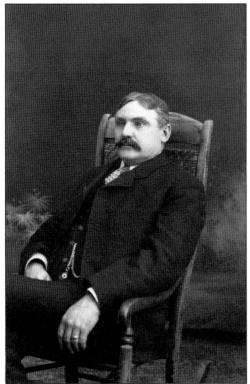

Carlton W. Luce, a prominent East Tawas citizen, was born in New York in October 1853. During his career, he served as superintendent of the Detroit & Mackinac Railway and the Erie & Michigan Railroad and as president of the Federal Sand & Gravel Company of Saginaw. He and his family resided in East Tawas for 35 years. Carlton Luce died on January 17, 1925, and was buried at Elm Lawn Cemetery in Detroit.

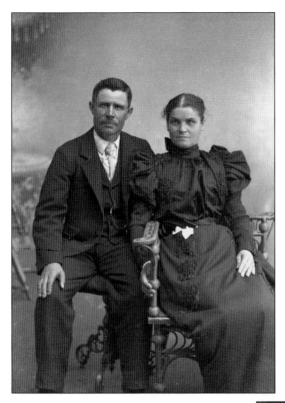

James Baguley, a pioneer railroad man from the Tawases, was born in Syerston, Nottinghamshire, England, on September 16, 1855. He married Hannah Hunt of Besthorpe, Nottinghamshire, on May 21, 1878, at East Stoke Church, where he had served as organist. From East Stoke, the couple journeyed to America in May 1883. James gave 42 years of faithful service as a fireman to the Bay City–Alpena and Detroit & Mackinac railroad lines. While affiliated with the Tawas City Methodist Church, he served as trustee, organist, and Sunday school superintendent. James Baguley passed away on February 18, 1938, at age 82. Hannah Baguley died on May 5, 1928, just two weeks before their golden wedding anniversary. Their only daughter, Frances (below), was born an invalid and died at age 16. The family rests at Memory Gardens Cemetery in Tawas City.

James Onesime LaBerge was born in Beauharnois, Quebec, on July 22, 1852. In 1871, he moved to East Tawas with his brothers, Louis and Napoleon. In 1875, he opened a boot and shoe shop on Newman Street, which he operated for many years. He married Mary Jane St. Martin in 1878, and together they had eight children. While living in East Tawas, James LaBerge served as mayor and postmaster.

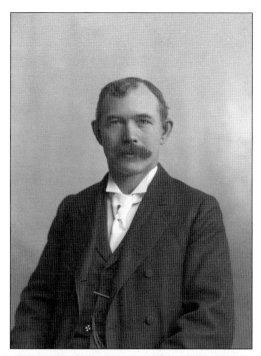

Pictured here is the family of James and Mary Jane LaBerge. Shown are, from left to right, (first row) Roy Alfred Napoleon (1891–1963), Henrietta Ann (1879–1930), Ruby Margareita (1895–1976), Albert Henry "Harry" (1882–1947), Eva M. (1884–1943), and James Roual (1880–1965); (second row) father James LaBerge (1852–1927), Georgina Mabel (1888–1971), Florence A. (1890–1975), and mother Mary Jane St. Martin (1860–1935).

Otto G. Kobs, age 28, and Mary Tamarack, age 19, both from Tawas Township, were united in marriage on November 30, 1902, at E.M. Lutheran Church. Rev. Albert Emmell officiated the ceremony. Otto Look and Emma Tamarack served as witnesses for the happy couple. The bride's parents, Mr. and Mrs. Charles Tamarack, hosted a reception at their home for a large number of family and friends.

John Kobs and Emma Bischoff were married on April 6, 1896, at Evangelical Zion Lutheran Church in Tawas City by Rev. C.L. Wuggazer. The groom was the son of Fred and Anna Kobs, and the bride was the daughter of William and Gusta Bischoff. Witnesses for the ceremony were Ferdinand Bischoff and Emma Waak, both from Tawas City.

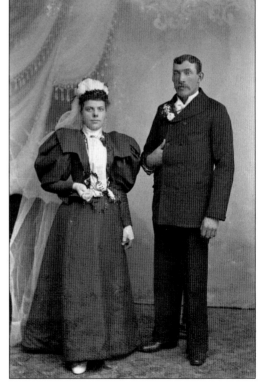

Married on November 20, 1898, at Evangelical Zion Lutheran Church by Rev. C.L. Wuggazer were Charles Zink Jr. and Clara Kaestner, both from Tawas City. The groom, age 26, was a fireman, and the bride, age 19, was a housekeeper. A reception was held at the home of the groom's parents, Mr. and Mrs. Charles Zink, where the city band made an appearance and rendered several tunes.

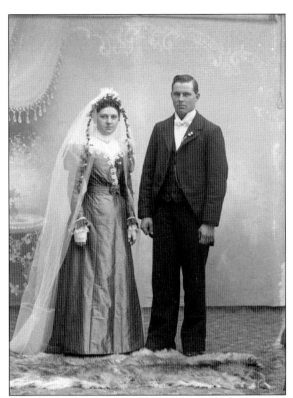

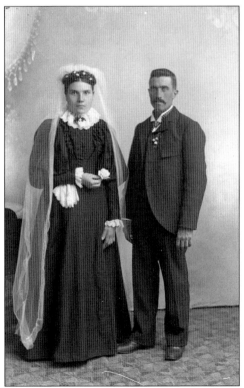

Otto Groenke (sometimes spelled Grenky), a farmer from Wilber Township, married Anna Frank, a housekeeper from Tawas City, on Wednesday, April 22, 1896, in Tawas City. Rev. William Assal performed the ceremony. At the time, the groom was 25 years of age, and the bride was 24. Otto Marwinski from Tawas City and John Groenke from Wilber Township served as witnesses.

Evelyn Jeannette Addison was born on May 6, 1898, to Dr. Stanley Herbert Addison and his wife, May Elizabeth Woodmancy. The couple had married in East Tawas on June 9, 1897. Eventually, their marriage ended in divorce. Dr. Addison was a physician in the Tawas area for many years. In 1918, Evelyn Jeannette married Ralph William Frazier in Detroit. She died in Los Angeles on September 17, 1957.

Noble Elmer Whittemore, born on February 3, 1894, in East Tawas, was the son of James Elmer and Nettie Whittemore. He was the great-grandson of Gideon Olin Whittemore, who arrived in Tawas City as its first settler in June 1854. Noble's grandfather was James Olin Whittemore, who was appointed the first postmaster of Tawas City on January 26, 1856. James Olin Whittemore also served as Iosco County clerk from 1857 to 1878.

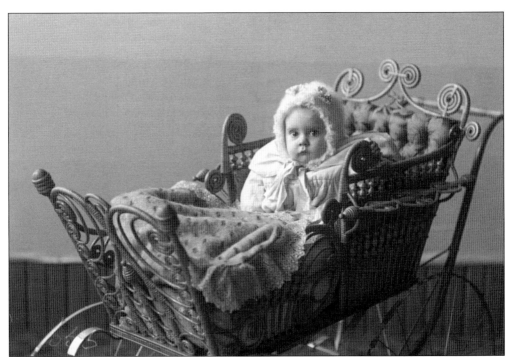

Fern Cornville was born to George L. and Julia Cornville on September 12, 1893, in Tawas City; she was their only daughter. George L. Cornville was born in New York in 1855 and married Julia A. Henry in 1892. He served as Iosco County clerk from 1887 to 1890. He was also an attorney and partnered in a law practice in AuSable with his brother-in-law Charles R. Henry. In December 1905, the family moved to Buena Vista, Colorado. Fern, shown in these photographs, lived a short time in Colorado with her parents before returning to Michigan. During her adulthood, Fern was a teacher and lived with Bertha May Ballard (1887–1972). She never married and died on September 1, 1980, in Washtenaw County, Michigan. Fern and Bertha rest peacefully beside each other at the Macon Cemetery in Macon Township, Lenawee County, Michigan.

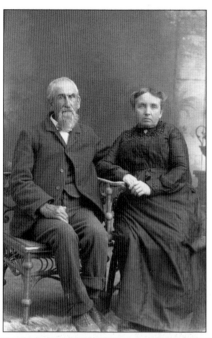

Duncan Sinclair was born on January 28, 1831, in Mosa, Middlesex County, Ontario, to Donald Sinclair and Christina Matheson, both from Scotland. On June 16, 1874, he married Jane "Jennie" Martin in Wallacetown, Elgin County, Ontario. Duncan, a sawyer, followed the lumber movement to Michigan in 1881. He applied for a homestead claim in Alcona County at Curtisville in 1897; five years later, the deed was registered.

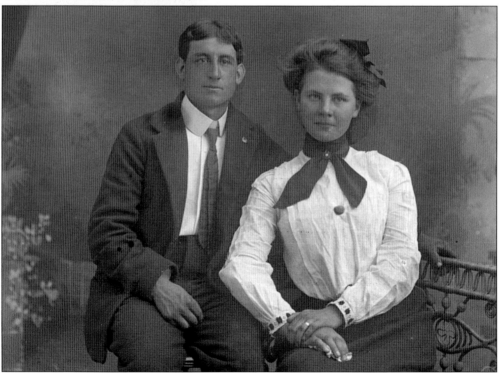

William Sinclair was one of four children born to Duncan and Jennie Sinclair (at the top of the page). William, born on January 4, 1880, in Deckerville, Michigan, married Christina MacColeman on April 30, 1903, in Curtisville. Their five daughters were born in Curtisville. William was a farmer, homesteader, and lumberman, and he worked on several dams along the Au Sable River. As builder of the Sinclair School near Curtisville, he served as its first director.

John Bowser (1842–1918) and his wife, Clarissa E. Merrett (1852–1926), were early pioneers of the Curtisville area. Besides being a farmer, John held several civic positions and kept an icehouse. Clarissa was also very community minded, as she organized a fund drive in 1890 to build a Baptist Church by soliciting donations from nearby logging camps. Evidently, John and Clarissa attended the Maccabees Third Annual Picnic held on Tawas Beach on August 15, 1901, as shown by the ribbon worn by Clarissa in this portrait. This event proved to be the largest gathering ever held at the popular Tawas Beach Resort. The Detroit & Mackinac Railway Company secured coaches to accommodate attendees. Games provided entertainment, including a competition for rube costumes. ("Rube" is slang for an unsophisticated person from a rural area.) The most comical rube costume won a bag of flour as the special prize, and $60 in cash prizes was awarded for the three best rube bands. Other games included melon-, apple-, and pie-eating contests.

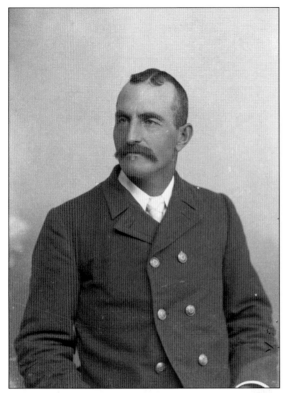

To this day, among the greatest mysteries of the Tawas Bay region is the disappearance of Capt. Frank J. Ocha in October 1896. At the time, Ocha was serving as commander of the lifesaving station at Ottawas Point, now known as Tawas Point. Routinely, Ocha navigated his sailboat from the point to East Tawas to visit his wife, Hattie, and their children, Ralph and Fay (below). After such a trip one evening, he failed to report for duty the next morning. His boat remained tethered to the dock, and his hat floated on the surface water of Tawas Bay, but the captain was nowhere to be found. Even after serious searching and dragging of the Tawas Bay by officials, his body was never recovered, and his whereabouts were never determined. Captain Ocha was 37 years old at the time of his disappearance.

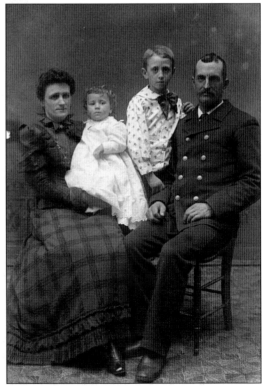

William F. Wendt was born in Hope, Midland County, Michigan, on July 11, 1877. On June 9, 1901, he married Martha Lemke at Zion Lutheran Church in Tawas City. After the wedding ceremony, the couple celebrated at the home of the bride's parents, Mr. and Mrs. August Lemke. Their union produced at least seven children. William Wendt was employed by the Detroit & Mackinac Railway as a fireman and an engineer. Later in life, he was a custodian at the courthouse. On May 16, 1902, Wendt caught a prize brown trout in Cold Creek. It measured over 28 inches long and weighed six pounds, three ounces. This fish was part of several thousand planted in the stream by Mayor Hartingh seven years earlier. The fish was displayed at Prescott & Sons mercantile store and admired by hundreds of people.

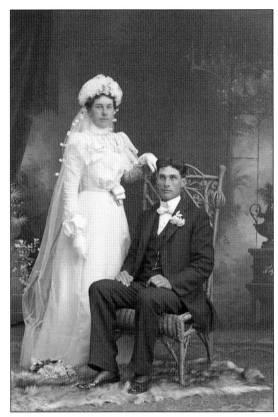

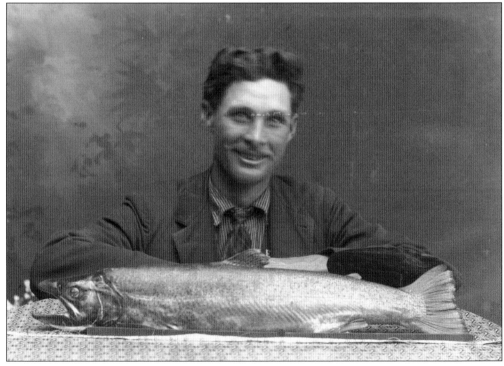

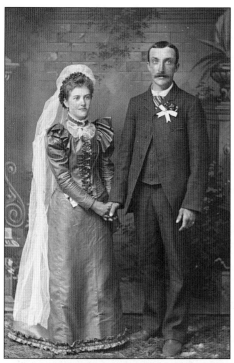

On June 18, 1893, John Anschuetz, age 25, married Augusta Johanna Kobs, age 17, in Tawas City. Both were born in Tawas Township. John was the son of Johannes L. Anschuetz (1829–1907) and Margaret Zorn (1836–1916), who homesteaded and farmed 160 acres in the southwest quadrant of Section 23 of Tawas Township. In 1968, this Anschuetz farm was honored as the first centennial farm in Iosco County.

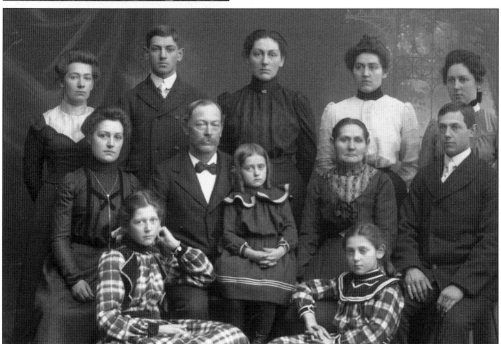

John Nicolas Anschuetz was born in Saxony, Germany, on April 4, 1849, and came to America in 1858. In 1865, he moved to East Tawas, where he married Caroline Klein on May 18, 1873. From this union, two sons and eight daughters were born. John served as the Detroit & Mackinac Railway warehouse manager for 35 years. After his death on February 22, 1922, he was buried at Zion Lutheran Cemetery.

Ernest Stephen Anschuetz, born in 1861, was the son of Johannes and Margaret Anschuetz, who farmed on the southwest quadrant of Section 23 in Tawas Township. Bertha A. Look, the daughter of Fred Look and Augusta Timmerck, was born in Germany on October 27, 1871, and immigrated to America in 1889. On November 13, 1892, she was united in marriage to Ernest Anschuetz. Together, the couple reared three children on their Hemlock Road farm. The children, seen in the photograph below, are, from left to right, Theodore G. (born 1898), Arthur E. (born 1902), and Erma V. (born 1896). A five-month-old-son, Reinhold Carl, died in February 1906 from double pneumonia. Bertha passed on May 25, 1916, in Detroit at the age of 44. Ernest Stephen succumbed to a paralytic stroke in December 1940. Both were buried in the Emanuel Lutheran Cemetery in Tawas City.

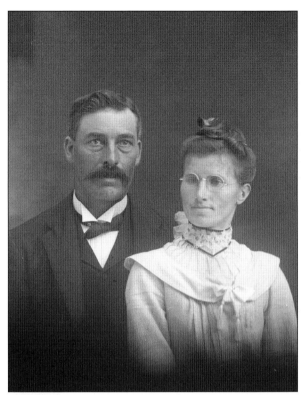

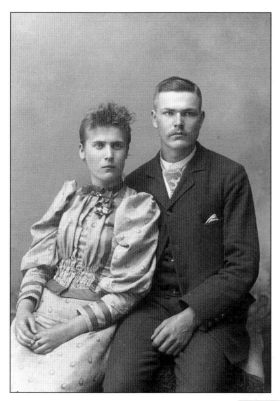

James Daley, a blacksmith and well driller, was born in St. Lawrence County, New York, in August 1872. A year later, he moved to Michigan with his parents. On March 26, 1894, he and Effie Mae Carroll were the first couple married at Hale Baptist Church in Plainfield Township. From Hale, the couple moved to East Tawas. Together, they had 11 children. In 1944, their son Stanley was killed during World War II in Saipan.

Ella Maud Carroll was the twin sister of Effie Mae Carroll. Both were born in Jeddo, St. Clair County, Michigan, on August 2, 1876, to Thomas and Viola Carroll. The Carroll family moved to the Hale area in 1879. On January 27, 1897, Ella Maud married Edwin Nunn, also from Hale. The wedding took place in AuSable, Iosco County.

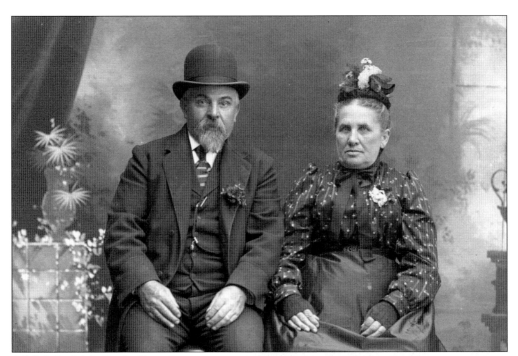

Adolph Rudolph Bischoff was born in the Kingdom of Prussia in December 1847 and migrated to America in 1873. He settled in Tawas Township of Iosco County. His first wife, Annie Hartman, died at the age of 41 in August 1899. Here, Adolph poses with his second wife, Mary Daubler Smith Rupbrecht Wiggers, from Indiana, whom he married in June 1901 on his farm.

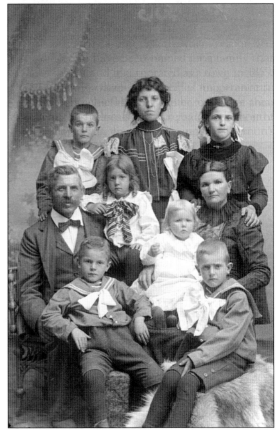

Just two years after coming to America from Germany, Ferdinand "Fred" Bischoff and Paulina Scheirer married on March 11, 1873, in Saginaw. Within a short time, they moved to Baldwin Township in Iosco County. During their 49-year marriage, Paulina gave birth to 16 children. Their marriage ended in divorce in 1922. Pictured here are, (from left to right, standing) Robert, Minnie, and Emilie; (sitting) Fred (left) holds Theodore, Henry leans on Fred's shoulder, Pauline holds baby Hedwig, and August is sitting on the deer hide.

The two photographs on this page were taken during the same sitting and probably on the wedding day of this couple, Jesse Chase and Sarah Cataline. Jesse, age 22 at the time, from Whittemore, was a laborer. He later operated his own freight business. Sarah Cataline, age 23, was the daughter of James and Emma Cataline. The couple was married on May 24, 1898, in Tawas City by Rev. Adoniram Waterbury, a Baptist pastor.

This couple, Durin O. Cataline and Bertha M. Chase, served as witnesses for the wedding of Jesse Chase and Sarah Cataline (shown at the top of the page). Note that both couples wear identical flowers in these photographs. Durin and Sarah were siblings. On July 2, 1898, this couple married in Tawas City, also by Rev. A. Waterbury. Both the bride and groom were from Whittemore. Jesse Chase and Martin Cataline served as witnesses.

Martin Leslie Cataline, a 24-year-old stonemason from Whittemore, married Sarah Amelia "Sadie" Whitford, a 20-year-old housemaid from Whittemore, on July 17, 1901, in Tawas City. The groom was the son of James Cataline and Emily Williams, and the bride was the daughter of Thomas Whitford and Elizabeth Sykes. Baptist minister Rev. A. Waterbury performed the ceremony at his parsonage.

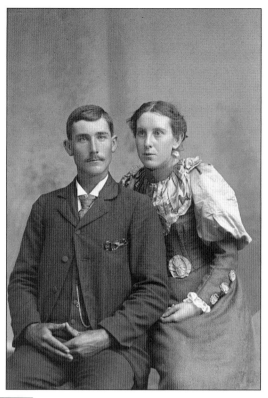

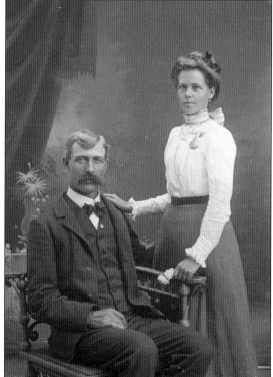

For nearly 20 years around the turn of the century, Thomas J. Spooner was the undertaker for Whittemore and Burleigh Township. He and his wife, Anne Eliza Voy, moved to Iosco County from Kent County, Ontario, where they had married in 1888. Their only child, a daughter named Leithea, died at four days of age in January 1889. From Burleigh Township, the couple moved to Plainfield Township.

Frank and Clara Fleck resided in East Tawas for only a short time as determined by the 1894 Michigan census. By 1900, they had moved their family to Lucas County, Ohio. Frank was a carpenter. Here, their two daughters, Annie and Edith, model fashionable outer garments of the era. Edith (left) was born on May 31, 1893, in East Tawas. Annie was born on March 31, 1890, in Canada.

Charles Hardin Culter, born on September 25, 1894, in Tawas City, was the son of Richard D. Culter and his wife, Carrie E. Anderson. Richard was a locomotive engineer. Sadly, Charles died on May 1, 1901, at the age of six years, seven months from scarlet fever. Charles's mother had given birth to five children, and all five died at a young age. Charles's parents divorced sometime before 1910.

Klint Bagger (pictured), born on February 18, 1889, in Tawas City, and Norman Bagger, born on February 14, 1897, in Florence, Montana, were the sons of grocer Wilhelm Bagger and his second wife, Marion E. Wilson. While living in Tawas City, the boys lived with their grandparents, Joseph and Matilda Wilson. Fred Bagger, an older half-brother to the boys, ordered this session at Emery's studio.

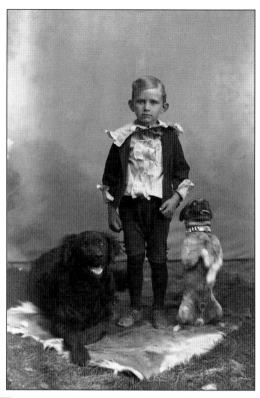

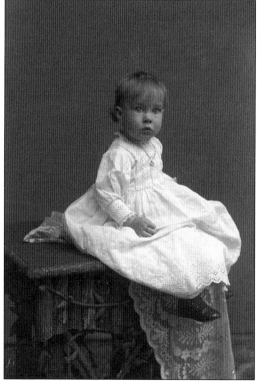

Thomas Burdon Dimmick, the son of Joseph G. and Lillian Burdon Dimmick, was born on March 22, 1893, in East Tawas. He was the grandson of East Tawas grocer and retailer Joseph Dimmick. A descendant of John Dimmick, Thomas joined the National Society of the Sons of the American Revolution. He was an engineer. After his death on May 18, 1958, he was buried in Mount Vernon Cemetery, Macomb County, Michigan.

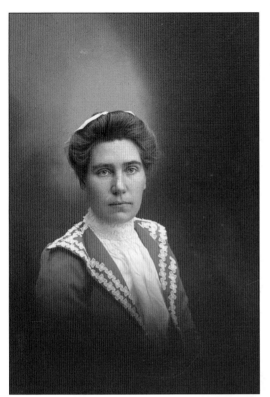

Lizzie Belknap was the daughter of Leonard V. and Catherine Belknap, pioneers of Reno Township. Born in New York in April 1876, she was also the sister of Howard M. and Almeda Belknap. On October 1, 1907, Lizzie, age 31, married Clement W. Baker, age 41, a rural mail carrier from Louisburg, Ohio. Lizzie was a schoolteacher. Lizzie and Clement made their home in Dayton after their wedding.

Lyle Belknap was the youngest of three sons born to Howard M. Belknap and Almira Bacher. Born in December 1890 in the settlement of Whittemore in Burleigh Township, Lyle followed the civil engineering career of his father, working as a highway engineer for Clinton County. His brother Leon engineered the famous Woodward Avenue in Detroit in 1925. Another brother, Leslie, designed the Huron Shore Trunk Line for the state highway commission in 1914.

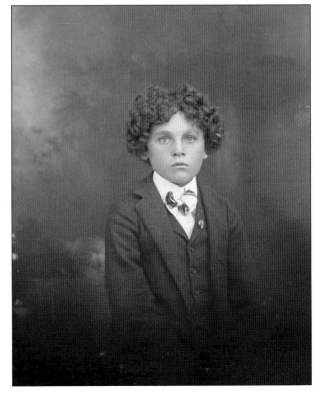

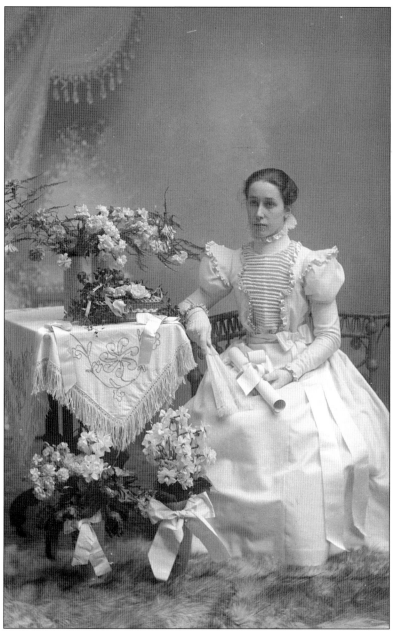

Lillian Goodale was one of 10 children born to Henry Buell and Francis Cyphers Goodale, both Iosco County natives. She was born on August 7, 1880, in California, when her parents lived there for a short time. When her family returned to East Tawas, Lillian resided with her grandfather Henry A. Goodale, who was a local physician and drugstore owner. During that time, she helped Dr. Goodale write his Civil War memoirs, which recorded his experiences as an assistant surgeon with the 21st and 11th Michigan Infantries. Lillian graduated from East Tawas High School in 1898. Sadly, she died at the early age of 21 from a three-day illness of appendicitis at Saginaw General Hospital on December 19, 1901. On the day of her funeral, December 23, Lillian's seven-year-old brother, Theron P., died from pneumonia in Wilber Township. Both were laid to rest at Greenwood Cemetery in East Tawas.

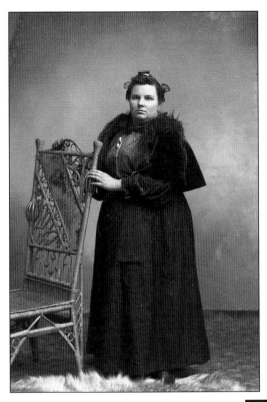

Effie May Test, born in June 1861 in Pennsylvania, married George Allen Prescott in 1883. In 1881, George Allen became general manager of the firm Charles H. Prescott & Sons. From 1895 to 1898, G.A. served as state senator, and from 1905 to 1908 he was secretary of state for Michigan. G.A. and Effie Prescott had two sons and resided in one of the three Prescott mansions located on Lake Street in Tawas City.

Anna Lydia Earhart was born to David Earhart and Elizabeth Lawson on November 15, 1882, in York County, Ontario. Posing here in her wedding gown, Anna married Angus Dunham on July 4, 1898, in Prescott, Ogemaw County, Michigan. Dunham was a farmer in Section 9 of Burleigh Township, as was David Earhart. Anna died on February 25, 1966, and was interred at Burleigh Township Cemetery.

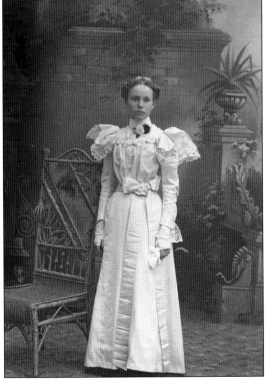

Before sewing machines, clothes were made by hand. Dressmakers were prevalent in every community, and each had their own style. Young girls worked for dressmakers to learn how to sew and to master the trade. Maggie Talbot is believed to be the woman modeling this stunning ensemble for a portrait. Talbot was a dressmaker from Kent County, Michigan.

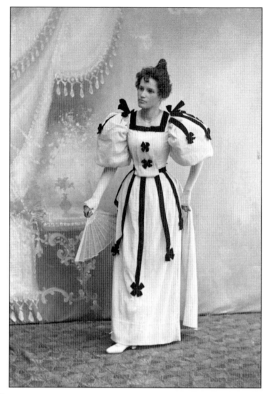

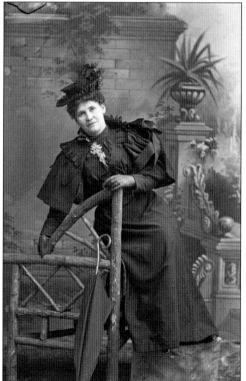

Nellie Bridget Moriarty met John T. Norton while working as a servant in the East Tawas household of Stephan Garlock. Norton was a druggist and a lodger in the same home. On May 5, 1881, they married. Their only son, Bert Earl, was born on April 12, 1881. A complaint of seduction against Norton was filed by Nellie on April 13, 1881. The case was obviously settled by marriage, because it was dismissed.

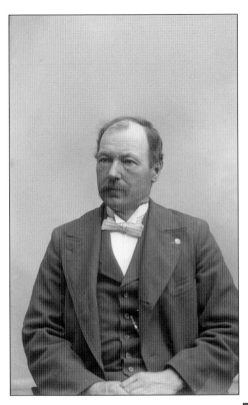

Reuben Wade was a farmer and leading citizen of Tawas Township. He served as justice of the peace, treasurer, and commissioner of highways and was a school board member. Wade was born in Macomb County, Michigan, in 1846. He served the Union Army in Company K of the 11th Michigan Volunteer Cavalry during the Civil War. He married Emma Kelly in 1868. Their union produced 11 children, all of whom died in childhood.

Born on October 1, 1849, in Ontario, Thomas Chalmers was a lumber camp laborer who followed the industry's movement to Michigan in 1880. In 1900, he worked at a camp in Curtisville, Alcona County. Chalmers died on November 26, 1910, in Tawas City from chronic Bright's disease. His remains were taken home to Vankleek Hill, Ontario, for burial.

Alexander C. Kay was born near Broughty Ferry, Scotland, in June 1832 and was a doctor of both medicine and divinity. In 1883, he immigrated to the United States aboard the ship *Circassia* from Glasgow. During his 22 years in the Tawas area, he organized the local Presbyterian society and served as pastor until his retirement in 1905. He died in East Tawas in October 1908 and was buried at Greenwood Cemetery in East Tawas.

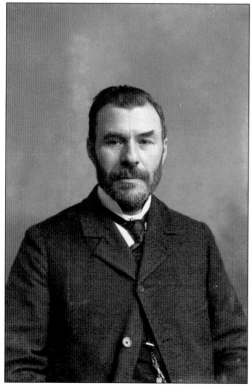

Rev. Carl L. Wuggazer was born in January 1849 in Germany and died in May 1921 in Lansing, Michigan. On October 26, 1890, Herman Dommer, who crafted the altar and pulpit of the new Zion Lutheran Church in Tawas, handed the keys to Pastor Wuggazer, who preached the dedicatory sermon. Wuggazer was called to Michigan in 1888 to establish and develop new congregations as he had done in Minnesota.

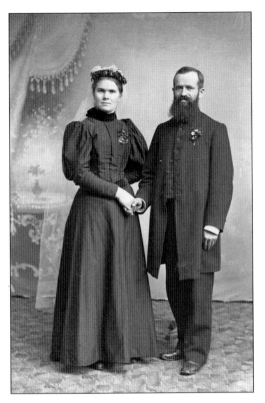

In Tawas City, on November 17, 1895, Rev. William Asall took Augusta Steffen as his bride. This was his second marriage. Prior to the wedding, Augusta had recently arrived to Iosco County from Germany. Asall, as pastor of First Evangelical Lutheran Emanuel Church, and Steffen were married in his church before the entire congregation by Reverend Mousa of Manistee. After the ceremony, the wedding guests were served an elegant supper at the Lutheran schoolhouse. The church and schoolhouse were handsomely decorated for the joyous occasion. By 1900, Reverend Asall and his wife departed Iosco County and moved to Osceola County, where he continued to serve as a minister. Asall was born on March 7, 1856, in Haltigen, Germany. He fathered one daughter from each of his two marriages and died on July 16, 1937, in Saginaw, Michigan.

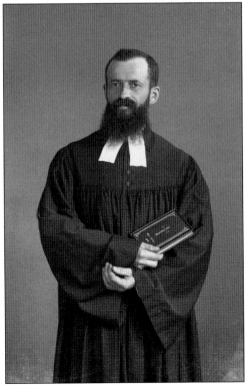

Henrietta Brown, seen at right,) was the wife of George H. Chamberlain, a notable lumberman, enterprising businessman, and local civic leader in northeast Michigan. At the age of 44, Chamberlain died in May 1896 in East Tawas. His remains were taken to Forest Lawn Cemetery in Saginaw for interment. At the time, he was one of the largest shippers of lumber from the shore area. Left to mourn his loss were Henrietta and their six children: Frederick, Etta, Beulah, Alta, Temple, and George. By 1910, Henrietta relocated to Saginaw, where she became a proprietor of a millinery shop. Her daughter Alta worked with her. Pictured below are the daughters of George and Henrietta Chamberlain: Alta (left), Beulah (center), and Etta.

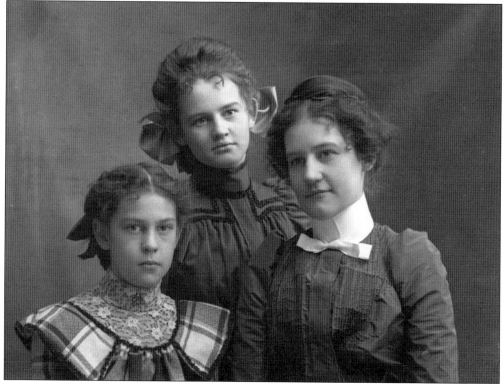

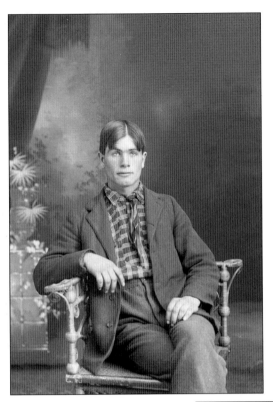

Archie Arnold was the second son of Canadian-born Andrew Arnold and his wife, Sarah A. Westcott. Born in Wilber Township on June 23, 1883, Archie worked in the woods during his young adult life. During his lifetime, he resided in Iosco, Ogemaw, and Crawford Counties. Archie married three times, died in 1961, and was buried beside his first wife, Tensie M. Smith, at Oakwood Cemetery in Crawford County, Michigan.

Homer Brazilla Eggleston was a railroad brakeman in 1900, when he lived with his parents and siblings in East Tawas. Born in January or July 1880 in East Saginaw to Harry and Lily Eggleston, Homer married Elizabeth Mead in Detroit on May 20, 1907. In 1910, he claimed his occupation as a railroad conductor. A few years later, he worked for Ford Motor Company as an assembler.

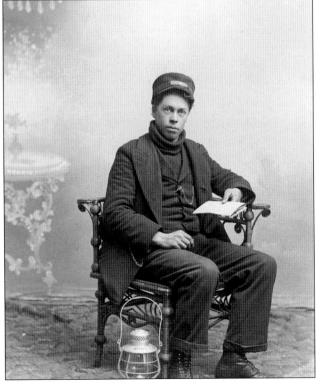

The white pine lumber industry spurred the growth of settlements and railroad transportation throughout the 1870s and 1880s in Iosco County. The lumber camps continued to thrive as the hardwoods were removed from the land. Many lumbermen, especially the French Canadians, remained to help clear land and build roads. Louis LaPratt (seated, center) and his crew were among those who stayed beyond the white pine harvest.

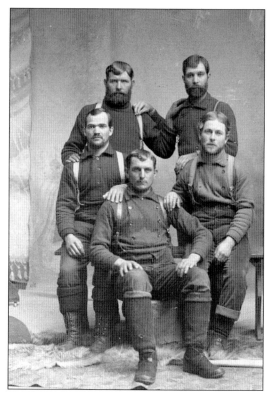

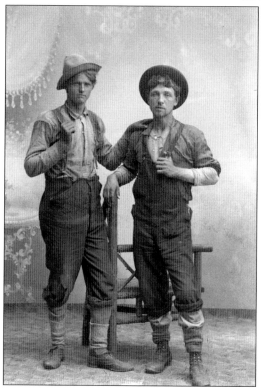

David A. Barrus (left) and James Wilkinson (right) were farm laborers in 1900. Both worked on the William and Martha Wilkinson farm in Mentor Township of Oscoda County. Barrus, born on August 25, 1882, in Bellevue, Eaton County, was a boarder with the Wilkinson family. Wilkinson, the son of William and Martha, was born in Wilber Township, Iosco County, on May 14, 1880.

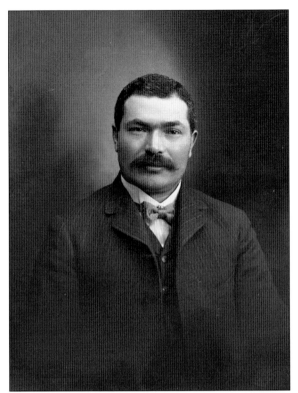

Abram Barkman was born in Poland in 1862 and journeyed to America with his parents around 1875. For over six decades, he was a well-respected businessman in the Tawas area. Abram and his first wife, Helena Rosenholz, produced two sons, Joseph and Nathan. Helena died in January 1901. Abram's second wife was Clara Myers, and together they had seven children. Abram died on May 7, 1941, in East Tawas.

David Everett Emerson, born in Maine in 1852, married Alice R. Welton in 1885 in Michigan. David and Alice had no children, and both were active in the East Tawas community. David was a justice of the peace in the 1880s and 1890s, worked for the local railroad, and was a grocer. In 1905, they moved to Alpena, where David died in 1925 and Alice died in 1937.

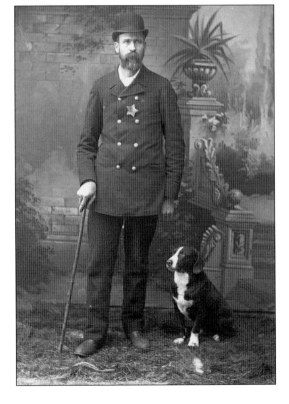

Orlo McMurray (right) was born in East Tawas on April 30, 1884, to Alexander McMurray and Anna Eliza Hodgens. Both his father and brother James B. were employed by the Detroit & Mackinac Railway. Orlo married Mary Ann Murray in November 1919, and together they had three sons. Orlo died in Detroit on October 3, 1926, at the age of 42. His friend in the photograph is unidentified.

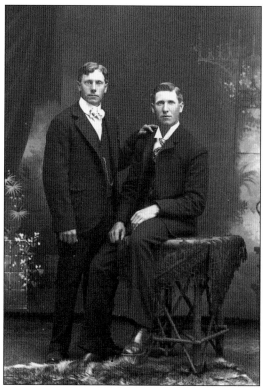

Brothers John Alstrom (left) and Oscar Alstrom (right) were sons of Aaron and Sophia Alstrom. Aaron immigrated to the United States in 1881 from Sweden and brought his family here in 1885. They settled in Baldwin Township. Oscar (born August 1870) eventually took over the family farm and served as Baldwin Township clerk. John (born October 1877) moved to Oakland County, Michigan, and became a barber.

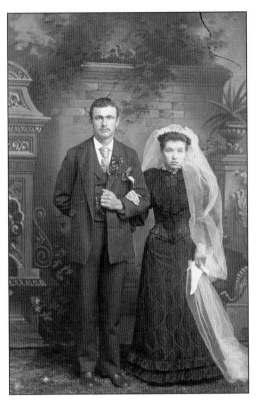

On September 10, 1893, William Boldt, age 22, of Tawas City, wed Amelia "Mollie" Heiden, age 19, of East Tawas. Boldt and Heiden, both born in Germany, came to this country in 1880 and 1889, respectively. Rev. William Assal performed the ceremony at the Emanuel Lutheran Church in Tawas City. He was a day laborer, and she was a dressmaker. After their wedding, the couple resided in East Tawas.

Groom Frederick Reinke, age 32, and bride Bertha A. Mueller, age 16, exchanged wedding vows on November 21, 1893, in Tawas City at Emanuel Lutheran Church. Rev. William Assal served as the officiant. Reinke, a day laborer, was the son of Karl Reinke and Ernstine Dahlmann. Mueller, a housekeeper, was the daughter of August Mueller and Johanna Woitzel. Both were born in Germany.

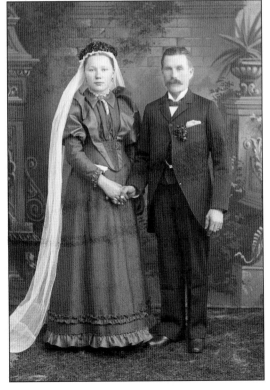

East Tawas residents Alfred "Fred" Noel Jr., age 23, and Grace Merritt, age 21, were wed at the home of her parents, George and Etta Merritt, on the evening of July 2, 1896. Sadly, Grace died in April 1900 in East Tawas. On September 27, 1900, Alfred married his second bride, Jessie Frazier, also age 23, in East Tawas. It is unknown which bride Alfred Noel poses with in this portrait.

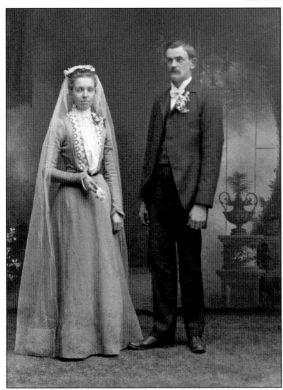

Gustave C. Karus, a farmer from Baldwin Township, and Anna A. Cholger, a servant from Wilber Township, were married at Emanuel Lutheran Church in Tawas City by Rev. John Karrer on November 29, 1900. Karus claimed Germany as his birthplace, and Cholger was born in Michigan. Karl Cholger and Martha Linke, both from Wilber Township, served as witnesses. Gustave enumerated both the 1900 and 1910 federal censuses for Baldwin Township.

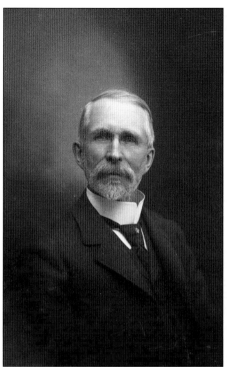

Benjamin F. Oakes ventured to East Tawas in 1876, where he comanaged the Emery Brothers lumber business for 14 years. Appointed postmaster of East Tawas on January 27, 1899, he served until December 17, 1913. Oakes was born in Oldtown, Penobscot County, Maine, on June 22, 1838, to Nathan and Martha Hewey Oakes. He attained the rank of captain while serving in the Civil War with the 1st Maine Heavy Artillery.

Louisa Oakes, firstborn daughter of Benjamin F. and Lottie Oakes, was born in Maine, but she spent most of her life in the Tawas area. She graduated from East Tawas High School in 1890 and taught there a short time. On June 6, 1901, she married Williard B. Murray, a well-respected jeweler originally from Leoni, Jackson County, Michigan. While in East Tawas, Murray repaired watches for the business of W.E. Mowrey.

Helon Norton Otis, born in July 1832 in Jefferson County, New York, joined the Union cause in the Civil War in September 1861. Soon after his discharge in August 1863, Otis married Sarah Jane Johnson. In November 1863, he reenlisted as sergeant with Company I of the New York Heavy Artillery. He suffered a serious head injury as a result of this service. Otis died at the Grand Rapids Veterans Home in 1918.

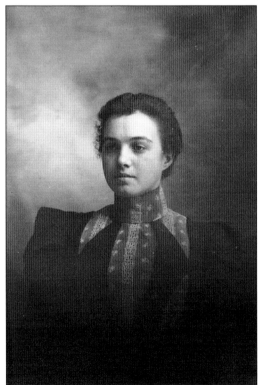

Edna M. Otis was one of four daughters born to Helon and Sarah Otis in Baldwin Township. After Edna's birth in 1880, the family moved to East Tawas. She graduated from East Tawas High School in 1896 and then worked for the *Iosco County Gazette*, becoming its editor in 1916. She wore many hats throughout her career, including teacher, author, and historian. She died in June 1974 at age 94.

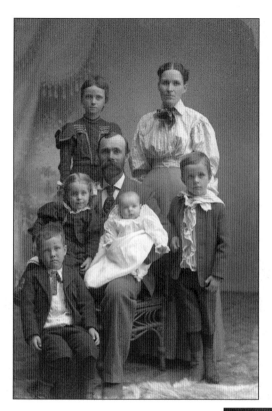

William and Wealthy "Annie" Latter established one of the finest farms in Reno Township, Iosco County. They were married on January 9, 1889, and their union produced nine children. The eldest five offspring are pictured here with the couple. They are, from left to right, Byron Floyd, Myrtle, Iva May, Florence (baby), and Frederick. Annie died on December 25, 1936, at the age of 69. William, 93, died in July 1955. Both are buried at Reno Township Cemetery.

Born in 1880, Arthur Latter was the eighth of ten children born to Arthur Edney Latter and Lucy Harriet King. At age 22, he married Sarah Frockins on October 22, 1902, in Tawas City. He was a farmer from Reno Township. Sarah, who was 18 at the time of their marriage, was also from Reno Township. She was the daughter of Thomas Frockins and Emma Robinson. The couple had three children. In March 1907, Sarah died from scarlet fever.

Seth F. Horton and his wife, Betsie Hornicker, were among the first settlers in Reno Township. They married in 1859. In 1879, the couple and their four children moved to the area from New York. Seth served in the Civil War with Company F of the 91st New York Infantry. Betsie Horton died in 1914, and Seth died in 1916. Both were buried at the Reno Township Cemetery.

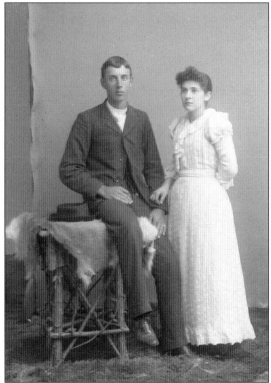

Delbert Horton, son of Seth Horton and Betsie Hornicker, was born in New York in 1874. At a young age, he moved with his parents to Reno Township. On July 3, 1895, Delbert married Eva J. Murphy of Whittemore. Unfortunately, their marriage lasted only six months and 10 days. Delbert died on January 13, 1896, from inflammation of the lungs. He rests in peace at the Reno Township Cemetery.

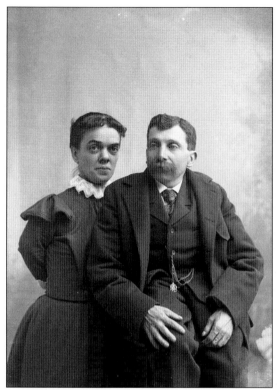

Elmer Odell was born in Ohio on March 4, 1864. On June 1, 1898, he married Edith Elva Moon. Both were "little people." Elmer Odell was a storekeeper, merchant, and postmaster in Siloam of Reno Township, Iosco County. He served as the postmaster of Siloam from April 22, 1898, until his death on October 1, 1902. After her husband's death, Edith Odell moved to East Tawas and opened a store in the Huston Block. She died on November 6, 1928, in Tawas City. Both were buried at the Reno Township Cemetery. The couple had one son, Elmer, who was born in Reno Township in 1902. The younger Elmer was also a little person. As an adult, he was employed by the Ringling Bros. and Barnum & Bailey Circus, calling himself Prince Elmer. Below, an unidentified couple poses with Elmer and Edith.

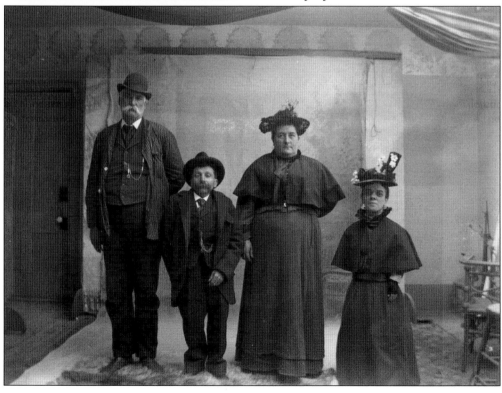

Nellie May Dillabough was the first wife of Reno Township pioneer Neil McDougald. Nellie was born in Lapeer, Michigan, on November 15, 1872, to Squire Maitland Dillabough, the first Reno Township supervisor, and Rosena Scott. Nellie and Neil had three children: John Maitland, Rosena Mary, and Leslie. After 24 years of marriage, Nellie McDougald died on April 5, 1902, from tuberculosis. She was laid to rest at Reno Township Cemetery.

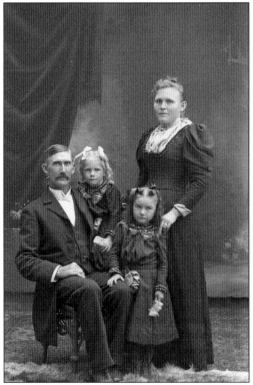

John J. Renno served as supervisor of Reno Township in 1903 and 1904. He resided in the township with his wife, Alice, and their two daughters, Marie (born 1893) and Beulah (born 1897). Renno was also a farmer, preacher, and aspiring optician who took orders for spectacles. The Renno family moved to Virginia in 1905. The William Staebler family from Owendale bought the Renno farm.

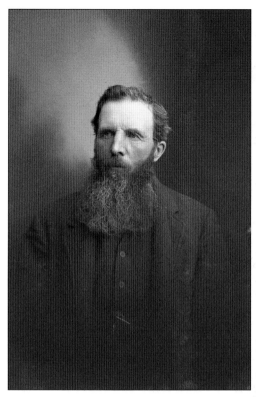

John Garfield Westervelt, seen at left, was the son of Jacob Westervelt and Roxiana Wakefield. He was born on September 27, 1844, in Hartland, Livingston County, Michigan. Since 1881, he was a blacksmith, farmer, and merchant in Section 29 of Wilber Township. His first wife, Anna Daunes, died on December 8, 1891, and was buried at Greenwood Cemetery in East Tawas. Iosco County clerk records show that John applied for a marriage license on November 19, 1894. His second bride was Mary May Falls, a teacher from Wilber Township; however, that marriage was never recorded. The couple had two children, Evelyn "Effie" Alberta (born October 1896) and Cecil Clyde (born June 1900). In the photograph below, Effie is on the left, and Cecil is on the right. John Westervelt died on March 19, 1927, in Reno Township and was buried in Plainfield Township.

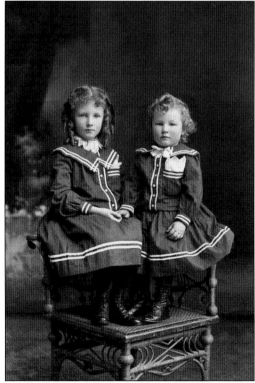

David William Love was born in Cattaraugus County, New York, in 1833. In January 1854, he married Emma Eliza Westervelt in Tyrone, Livingston County, Michigan. They moved to Iosco County in 1871 with their two sons, John J. and Charles D. In October 1883, the family moved to Plainfield Township. David Love died on his farm in 1914; his wife died in 1915. Both rest at Esmond Evergreen Cemetery in Plainfield Township.

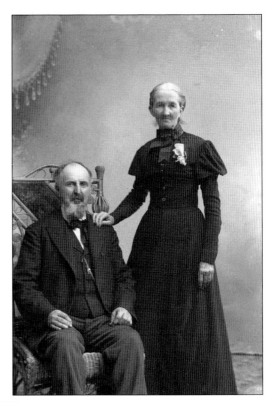

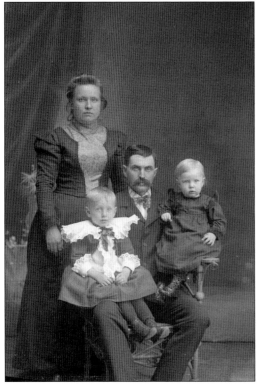

Charles D. Love, born in September 1866, married twice. His first wife was Ella May Graves. She died from childbirth, along with their five-day-old son, Ellsworth, on July 25, 1892. He married his second wife, Bertha May Soper, on September 29, 1897, in Reno Township. Here, Charles, Bertha, and their two oldest children, Merlin (left) and Claude, pose for a photograph.

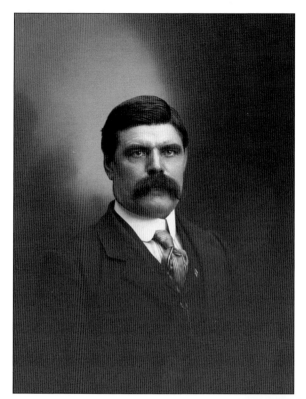

Fred E. Hess was a sawmill and threshing machine owner from Burleigh Township. He was born on December 6, 1861, in Saginaw to William Hess and Sarah Hammond. On December 7, 1902, he was filing a saw at his mill near Styles Lake when the engineer unintentionally started the machine, severing Hess's left leg below the knee. He died the following day and was buried in the Burleigh Township Cemetery beside his daughter Grace.

On August 14, 1884, William Harry Price landed on the Prescott dock in Tawas City aboard the old sidewheeler *Metropolis*. He was with his mother and four siblings. The family had come from North Hastings, Ontario. In August 1901, he married Florence Oakes, a schoolteacher and daughter of East Tawas baker George E. Oakes. Price served as postmaster for Whittemore from November 5, 1902, until February 5, 1915.

Nepthale Pierre St. James, also known as Peter, married Lydia Strong in 1892. Their only son, Noe, was born in September 1897. In 1900, the couple resided and farmed in Section 4 of Burleigh Township. After N.P. died on December 31, 1917, in Burleigh Township, Lydia and her son operated the family farm. All are buried at St. James Catholic Cemetery, south of Whittemore.

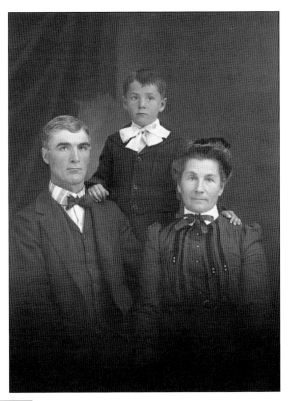

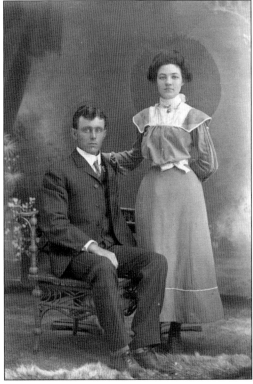

Mahlon Earhart was born in August 1878 in York County, Ontario, to David Earhart and Elizabeth Lawson. The family immigrated to Michigan in 1883 and farmed in Sections 9 and 16 of Burleigh Township. Mahlon married Almena Hitchcock on December 20, 1903, in Reno Township. Mahlon and Almena died in 1954 and 1946, respectively, and were buried beside each other at the Latter-day Saints Cemetery south of Whittemore.

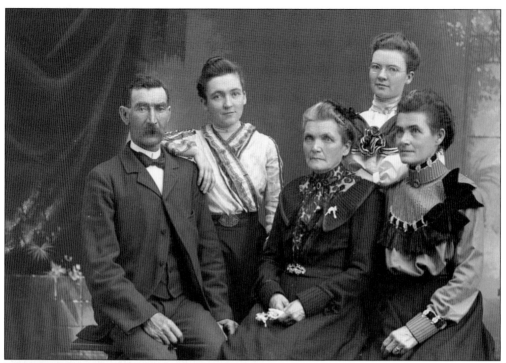

Ellen Ross (seated, center) was born in Longford County, Ireland, in February 1844. In 1869, she ventured to Alpena to visit her sister Sarah, wife of Judge Jonathan Brown Tuttle. While there, on May 19, 1869, she married John B. McLean (left), her childhood friend. In 1892, the family moved to East Tawas. The couple poses here with their two daughters, Lizzie (second from left) and Sadie (second from right), and Ellen's sister Maria Ross.

Archie McLean resided in Burleigh Township, as did his brothers John, Hugh, Neil, and Charles. On July 1, 1883, Archie married Rosa Stonehouse in Richland Township, Ogemaw County. The couple had two sons, William (born December 1878) and Perry (born February 1899). The family moved to Onaway and operated a hotel there. Shown here are, from left to right, Anna Lydia Earhart (half-sister to Rosa), Archie, son William Henry, and Rosa.

Thomas J. Armstrong was born in 1854 in Canada to Scottish parents. He married Elizabeth Barron in Ontario, and the couple had five children. Here, Thomas and Elizabeth pose with their children, from left to right, Ruby (born 1886), Chester (born 1888), Wellington (born 1890), Crawford (born 1892), and Dolphos (born 1894). Thomas owned and operated a blacksmith shop in Tawas City. He died in 1946 and was buried in Greenwood Cemetery, East Tawas.

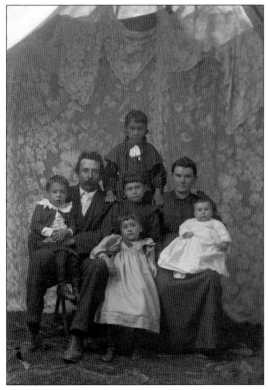

Samuel Sylvester and Amelia Bamberger resided in Grant Township, Iosco County, as early as 1880, along with Samuel's brothers Charles Elias, James, Peter Emery, and William Henry. Samuel and Amelia raised a family of six children, the first five of who pose here. The Bambergers were hardworking Irish people from Canada. Samuel and Amelia rest peacefully at Memory Gardens Cemetery in Tawas City.

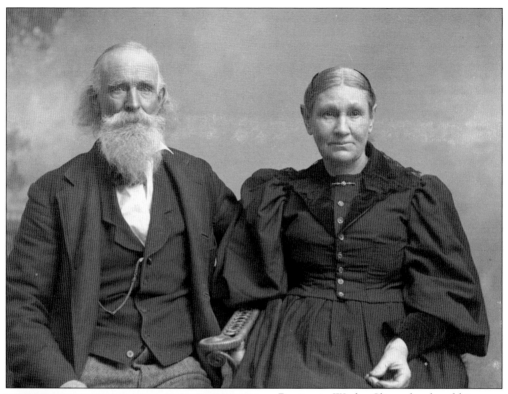

Benjamin Wesley Slingerland and his wife of over 75 years, Elizabeth Fairchild, moved to Alabaster Township in 1852, when the area was a dense wilderness and the nearest trading center was Bay City. Benjamin fished, traded, and farmed to earn a living and was one of the county's earliest pioneers. Elizabeth died in March 1918, and Benjamin died in November 1918, about 10 months before his 100th birthday.

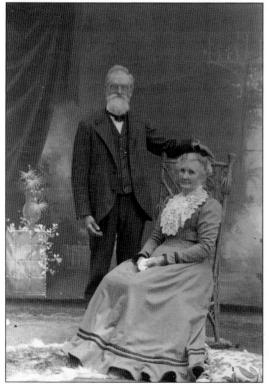

Charles F. Adams and his wife, Ann M. Maywood, moved to East Tawas in 1863 after he served the Union army in the Civil War. Charles was born in 1827 in Salisbury, Massachusetts, and Ann was born in 1837 in Quebec, Canada. The couple married in Ontario in 1855. Ann was the first white woman to reside in East Tawas. While living in this area, Charles worked in a sawmill.

Jeremiah Frederick "Fred" Harrington, age 27, and Adeline Smith, age 21, united in marriage on August 22, 1895, in East Tawas. Fred, a band sawyer, was born in Port Huron, Michigan, the son of Charles P. Harrington and Mary Sedgman. Adeline, a housekeeper, was born in Brantford, Ontario, to Josiah Smith and Eliza Hull. The couple raised their family in East Tawas.

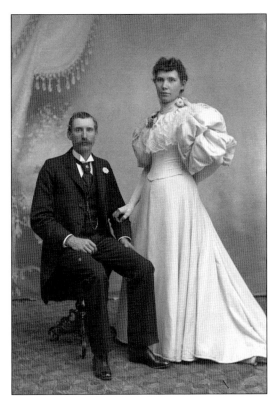

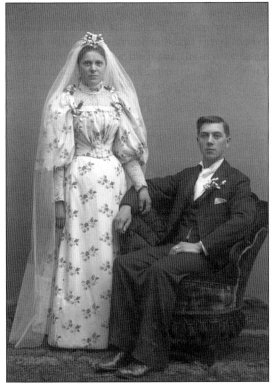

Married at the home of her parents were Amelia Kraum, age 20, a housekeeper from Alpena, and Fred Marzinski Jr., age 24, a clerk from Tawas City. The ceremony took place on July 10, 1895, at the residence of Mr. and Mrs. Charles Kraum in Alpena. Marzinski worked for Charles H. Prescott & Sons for 11 years before forming a partnership with Julius Musolf in the grocery business in 1902.

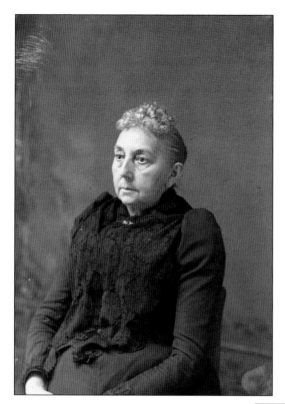

Charlotte VanWagoner was born in New York in March 1834. In 1853, she married Archibald G. VanWey. He was also born in New York before settling in Saginaw in 1853, where he accumulated much wealth as a lumberman and hotelkeeper. They moved to Tawas in 1872 and operated the Bayside House for 23 years. Archibald died in December 1900, and Charlotte died in July 1914. Both are buried at Memory Gardens, Tawas City.

Marion L. Davis, born in 1842 most likely in Lapeer County, Michigan, married Maynard Butts on July 4, 1859, in Lapeer. Maynard enlisted in Company I of the Michigan 1st Engineers and served three years in the Civil War. He was city marshal in Lapeer before moving to Whittemore. Maynard and Marion had one daughter, Eva. After their deaths, they were interred in Mount Hope Cemetery in Lapeer.

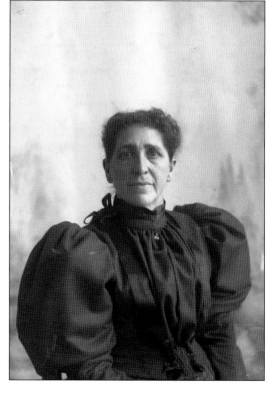

Capt. James A. Carpenter served in the US Life-Saving Service and was a keeper of the Tawas Point Station from 1890 to 1915. He was also superintendent of the East Tawas Water Works. Born in 1864 in New York, he was the son of Oren N. Carpenter and Sarah Packer. He married twice, first to Katherine Slackford (pictured) in 1892 and then Anna Van Wyck in 1919. He died in East Tawas in 1922.

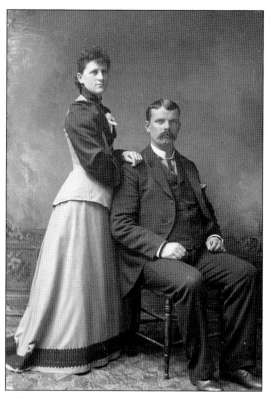

Julia M. Fox (left) and Nina M. Fox, daughters of William J. Fox and Martha Lester, were born in 1880 and 1883, respectively. In November 1907, Nina, a schoolteacher, married Albert W. Black, who graduated from law school in 1904 and became Iosco County prosecuting attorney in 1912. Nina and Albert moved to Bay City in 1917, and Julia lived with them. Julia never married.

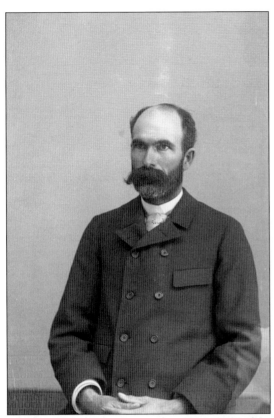

Dr. Dewitt C. Howell moved to East Tawas in June 1892 as the chief surgeon for the Detroit & Mackinac Railway. He was a general practitioner who made house calls with his horse and buggy. A skilled surgeon, he often invited the public to view the procedure. Dr. Howell was born in February 1856 in Michigan. He and his wife, Cora, had three children.

Dr. John H. Botz was born in Grey, Huron County, Ontario, in October 1864. He graduated from Philadelphia Dental College and was a dentist in East Tawas. On June 24, 1891, he married Cecilia Priscilla Price of Whittemore. Dr. Botz, a leader of the Iosco County Christian Endeavor Union, poses here with some of his youth delegates. He died on February 7, 1933, in Brentwood, Maryland.

These six young ladies made up the 1896 graduating class at East Tawas High School. They are Alice Nesbit, Winnie Mack, Edna Otis, Florence Oakes, Maude Green, and Stella Oakes. Each graduated with high honors. The ceremony was held at the opera house, which was lavishly decorated with flowers and bunting of the class colors, yellow and white. The class motto was, "Not how much, but how well."

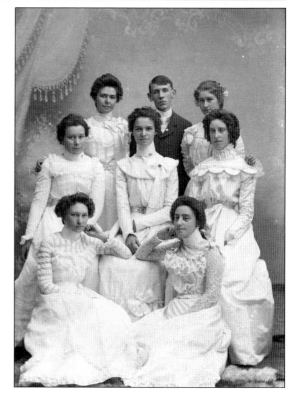

In 1900, eight members of East Tawas High School earned their high school diploma. Members of the class of 1900 were Luella Green, Bertha Tait, Lizzie Nash, Hattie Eagan, Grace Green, Bell Myers, Wacie Halligan, and Will Dillon. At the time, the wood-framed East Tawas High School was located on the west side of the third block of Newman Street. Around 1909, it was replaced with a brick building.

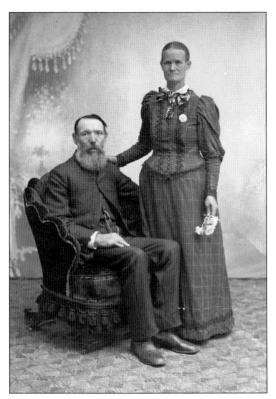

Gottlieb Louis Lange, born in Germany in 1835, and Johanna Matscherodt, born in Germany about 1839, married in their native country in 1862. Of their 10 children, 4 were born in Germany. Around 1872, the family moved to the Tawas area. Gottlieb Louis was a blacksmith and farmer. He died in Tawas City on September 28, 1908, and Johanna died on January 2, 1924, in Saginaw.

Theodor Oscar Lange was born in Tawas Township on June 2, 1877, to Gottlieb Louis and Johanna Lange. On August 28, 1898, in Tawas, he married Emma Stuedemann, daughter of Joseph and Sophia Cupp Stuedemann. The couple raised six children. Emma died on February 15, 1932, and Theodor died on April 16, 1956. Theodor dropped the "E" from his surname and used Lang to denote his family.

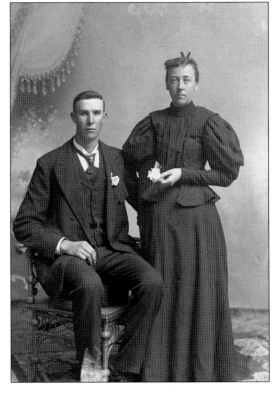

James Henry Morrison was born in Grey County, Ontario, to John Morrison and Mary Hill. He moved to Plainfield Township in 1887 with his father and new stepmother, Sarah Jane Hunt. On December 29, 1897, he married Mary Hannah "Minnie" Stephens of Hale. Together, they had three children: Vina, Rose, and John Risdon. After Minnie's death in 1916, James continued to farm in Plainfield Township until his death in January 1950.

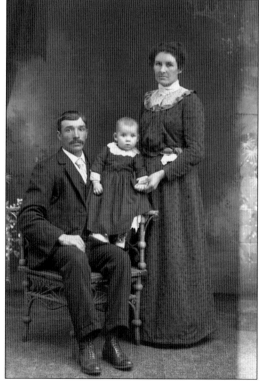

Mary Ann Morrison, daughter of John Morrison and Sarah Jane Hunt, was a half-sister to James Morrison. She married Cashus Leroy Brandal, and they had five children: Clarice, Bessie, Laura, James L., and John B. Clarice, who was born on February 6, 1901, poses here with her parents. Mary died on November 5, 1935, in Flint. Cashus died on May 11, 1958. Both were interred in Esmond Evergreen Cemetery in Plainfield Township.

Sarah Marie "Sally" North was born on November 24, 1900, in East Tawas to John O.H. North and Mary Jane Devereaux. Her siblings were Dorothy (born February 1903) and John Cornelius (born October 1908). On June 10, 1925, in Alpena, Sarah married John T. Croll, a civil engineer from Comins, Michigan. Their union produced two children. At age 101, Sarah died on May 28, 2001.

Jennie Esmond was the daughter of Clark Esmond and his second wife, Carrie Burcham. Jennie was born on May 3, 1895, in Duluth, Minnesota. Clark Esmond was awarded 160 acres in Section 19 of Plainfield Township for serving in the Civil War with Company D, Michigan 7th Cavalry. He settled there in 1871 and engaged in lumbering and farming. Clark Esmond moved his family to Tawas City when he was elected sheriff in 1882.

Thomas P. Cox was fatally shot by an Italian miner in Laurium, Houghton County, Michigan, on October 18, 1903. His wife, Mary E. Robinson, and three young daughters accompanied the body from Laurium to Tawas City, where he was buried. Cox, born in Canada in 1857, served two terms as Iosco County sheriff, ending in 1896. Pictured here from left to right are his three daughters: Catherine (born 1892), Helen (born 1886), and Lulu (born 1891).

This photography session was ordered by Eva Corno in the early 1900s. Members of the Huron Shores Genealogical Society have been unable to identify the charming lad posing for this portrait in Ard Emery's studio. Since this photograph demonstrates Emery's creativity behind the camera lens, many felt that it should be included in this book.

Historically, deer hunting has been a treasured sport by most men in northeast Michigan. In the mid-1890s, John Schneider's trophy whitetail buck earned a session in Emery's studio. Schneider (center) was one of a dozen children born to Mathias and Anna Schneider of Sherman Township. John never married, and he died at age 38 from heart disease on January 5, 1911. John's friends in this portrait are unidentified.

John G. Emery (left), brother of Ard Emery, and James A. Sayles pose with a prize-sized muskie in Emery's studio. John (1828–1893) lived most of his life in Peshtigo, Wisconsin, where he erected and operated sawmills for the Peshtigo Lumber Company. Sayles, born in November 1848 in Bay County, Michigan, was a lumber inspector and eventually owned the building that housed Emery's studio.

Eddie Theodore Pierson (born April 1886) was the son of Nels Pierson and Matilda Handel of Baldwin Township. He married Dorothy Lawson, a schoolteacher from Sheridan, Montcalm County, Michigan, on August 17, 1916. Obviously, he played baseball for Baldwin. In early adulthood, he worked for Prescott & Sons Hardware. Later in life, he was a plumber. Pierson died on April 2, 1976, and was buried at Greenwood Cemetery in East Tawas.

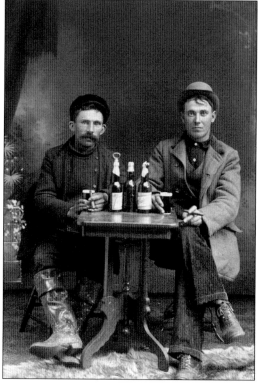

Longtime fisherman James Howard Brown (left) was born in Canada on April 17, 1873. In 1896, he married Nellie Lake, and together they had at least nine children. The family resided in Ward 3 of Tawas City for many decades. James died on June 17, 1936. Here, he poses with an unidentified friend in Ard Emery's studio in East Tawas.

Alva Gustavos Wood, born in 1832 in Ontario, was a lumberman. He married Martha Jane Weatherwax, and they moved to East Tawas in 1878. Eventually, Alva became a prominent real estate developer. In the photograph at left, Alva poses with his grandson Alva Wood II, who became a farmer in the Tawas area. Below, three daughters of Alva Wood pose for a portrait. Frances "Fannie" Wood (left), born in Ontario in 1858, married John McDonnell in East Tawas in 1888. Mary "May" Wood (center), born in Ontario in 1873, was a saleswoman and manager of the Davis, Kishlar & Company dry goods store in East Tawas. In 1905, Mary married James Poppleton, storekeeper for the Detroit & Mackinac Railway. Jennie Gertrude Wood (right), born in Ontario in 1867, became a teacher in East Tawas and married Guy Davis of Davis, Kishlar & Company.

In 1868, William Henry Clough (1851–1931) moved to the Tawas area with his mother, Elizabeth Bywater, and her second husband, Marvin Wilber. After marrying Mary Ann Navin in June 1875 in Amherstburg, Ontario, the couple raised their six sons in East Tawas. Here, the four youngest sons pose for a photograph. They are, from left to right, (seated) Charles Marvin (1885–1962) and John Hubert "Herbert" (1887–1965); (standing) Russell Stephen (1891–1970) and Ralph Earl (1889–1962).

Minnie Clough (left) and Mary Ann Navin embrace the fashionable large, puffy sleeves of the early 1900s in this portrait. Minnie, a sister of William Henry Clough, was born in Memphis, Macomb County, Michigan, in December 1854. Mary Ann was born in January 1854 and married William Henry Clough in 1875. Minnie and Mary Ann were sisters-in-law.

William Vern Freel was born in 1848 in Ontario to Hugh Freel and Betsy Pettit. He married Matilda Lane in 1870, and together they had 12 children. William and Matilda farmed in Tawas Township. Shown here are, from left to right, (first row) Carmen Judson, Mary Epsey, and Charles A.; (second row) Minnie (wife of James A., holding son Earl), Matilda, William V., and George N.; (third row) James A., Joseph, Alexander A., and August A.

Gustave Gaul and Adeline Ernestine Gaul, both born in Germany, were married there in 1879. In 1880, after the birth of their first daughter, Helena, the family immigrated to America, eventually moving to Tawas City in 1882. Shown here are, from left to right, (seated) Gustave, Alvina (born July 1894), Antonia (born August 1892), and Adeline; (standing) Reno (born June 1882) and Helena.

John Duvall and Alice Treend, both born in Canada, were married in 1893. This photograph, taken in Ard Emery's studio prior to 1900, shows the couple with their three oldest children, Burton (left), Rosena (center), and John. In February 1900, their youngest daughter, May, was born. Sadly, within a year, in March 1901, Alice died in Grant Township from kidney cancer and was interred in Argyle Township, Sanilac County.

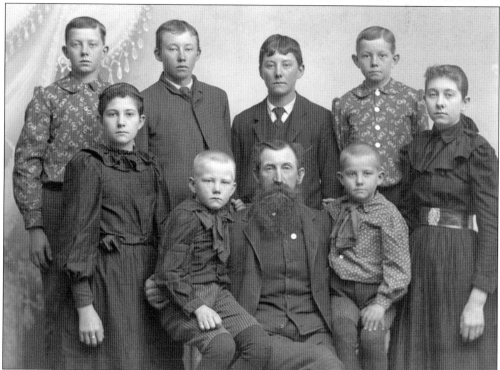

John Scarlett and his family farmed 80 acres in the north quadrant of Section 25 in Grant Township. The post office of Edson was located within that parcel on Hemlock Road. John, born in December 1848 in Canada, married Mary Ann Curry. Together, they had eight children. Mary Ann died in June 1895, and John died in January 1907. They lie beside each other at Memory Gardens Cemetery.

At the turn of the century, when large hats amassed with huge feathers were popular, Lottie Hall modeled this hat, adorned with wings from a chicken. Charlotte A. "Lottie" Hall, born in April 1883 in Au Gres, was the daughter of George A. Hall and Ada Roth of Grant Township. After the death of her first husband, Charles Louis Pringle, she married Henry Patrick Flynn.

Amelia Cadorette and seven of her friends pose in Ard Emery's studio wearing wide-brimmed straw hats trimmed with ribbons and flowers. Hats like these were trendy for the time. It is not evident which young lady is Amelia, who resided in the Tawas area her entire life. She married Daniel Cater in East Tawas on July 21, 1902, and together they had five sons.

Ard G. Emery had a knack for capturing the attention of babies and pets with his glass-negative camera. The portrait above of seven infants, taken about 1895 at the Harrisville Baby Show, demonstrates his patience, timing, and talent as a photographer. Emery posed dogs with their owners in many portraits. Evidently, with a keen sense for understanding the behavior of canines, Emery persuaded his furry friends to remain calm for a few seconds to capture the image. Because photography during this time was considered more economical and definitely easier than it had been a decade prior, Emery rarely missed a chance to add some whimsy and creativity to his work. His opportunity to focus on the extraordinary was often achieved.

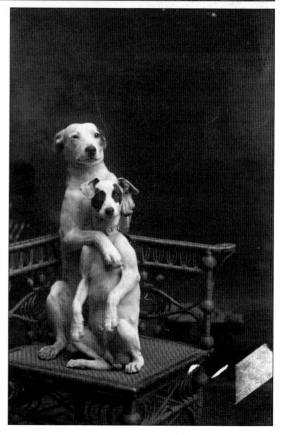

Discover Thousands of Local History Books Featuring Millions of Vintage Images

Arcadia Publishing, the leading local history publisher in the United States, is committed to making history accessible and meaningful through publishing books that celebrate and preserve the heritage of America's people and places.

Find more books like this at
www.arcadiapublishing.com

Search for your hometown history, your old stomping grounds, and even your favorite sports team.

Consistent with our mission to preserve history on a local level, this book was printed in South Carolina on American-made paper and manufactured entirely in the United States. Products carrying the accredited Forest Stewardship Council (FSC) label are printed on 100 percent FSC-certified paper.